ANATOMY
OF COMICS

9ᵉ ART RÉFÉRENCES

DIRECTION
Bernard Mahé

ARCHIVE MANAGER
Mathilde Kienlen

SCIENTIFIC ADVISER
Vicente Sanchis

FLAMMARION

EXECUTIVE DIRECTOR
STYLE & DESIGN COLLECTION
Suzanne Tise-Isoré

EDITORIAL COORDINATION
Lara Lo Calzo

EDITORIAL ASSISTANT
Virginie Picat

GRAPHIC DESIGN
Maya Palma

COPY EDITING AND PROOFREADING
Lindsay Porter

PRODUCTION
Corinne Trovarelli

COLOR SEPARATION
Atelier Frédéric Claudel, Paris

FOREWORD

The comic, like its siblings, literature and cinema, was born with a dual nature. On the one hand, realistic, depicting everyday people and situations, and revealing paradoxical or humorous aspects of the events portrayed. On the other hand, fantastical, exploring the space of imagination, dreams, and myths. It is this dual nature that has made the comic a visionary language, which explains both its more-than-a-century of success and its extraordinary ability to adapt, progressing from newspapers to magazines, to albums and to books.

Nevertheless, acknowledgement of the comic's cultural and artistic value has by no means been easily won. A number of visionary creators, from all manner of disciplines, have been inspired by this, adding references to the great maestros into their works. Until recently, this acknowledgment by creators has seen nothing similar when it comes to institutional culture. Comics were viewed as part of popular art, fleeting, and lacking integrity. At the same time there was a burgeoning interest among readers, booksellers, and collectors: old editions and original drawings were rediscovered and appreciated as works of art. On that basis, specialists placed the comic within cultural history's continuity, studying its graphic storytelling, what the heroes and their adventures symbolize, and presenting the comic as a highly potent means of expression that distils the yearnings and fears, dreams and desires of millions of people the world over.

The "la Caixa" Foundation has opened up the spaces of its CaixaForum cultural centers to contemporary cultural forms: from art and photography to opera and ballet, from design and architecture to video games,

from cinema to science and technology. What this approach to culture—hailing from every language and discipline—could never overlook is the comic, which is the subject of this exhibition. Comics, Dreams and History *is based on Bernard Mahé's vast collection, along with contributions from various institutions and private collectors, and is exhibited throughout the CaixaForum network. A major element of the exhibition is the Spanish comic, one of the European traditions with the highest international profile.*

This book has been produced to accompany it, bringing together a selection of masterpieces from the history of comics, starting with Richard Felton's series The Yellow Kid *from 1896, up to Régis Loisel's 2017 anthology* La Quête de l'Oiseau du Temps. *It spans the comic strip's golden age, including the great characters from the 1930s, the genre's vision of World War II, the evolution of the superhero, the Franco-Belgian school, the 1960s boom, and the graphic novel. The notion of a masterpiece, until recently narrowly encompassing only the major works of painting and sculpture, now responds to this desire to acknowledge the creativity and social significance of comics.*

I would like to express particular gratitude for the collaboration of Bernard Mahé, who instigated this project. Without him and without his generosity, we would not have been able to put together an exhibition of this scale.

Elisa Durán Montolío
Deputy Director General of the "la Caixa" Foundation

ANATOMY
OF COMICS

FAMOUS ORIGINALS OF NARRATIVE ART

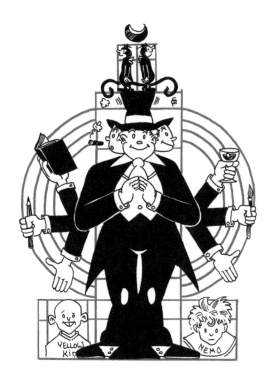

DAMIEN MACDONALD

Flammarion

Today, comics are one of the very few forms of mass communication in which individual voices still have a chance to be heard.

Scott McCloud

DISSECTING TABLE OF CONTENTS

ACKNOWLEDGMENTS

This book was made possible through
my collaboration with the 9e Art Références collection.
For the second time in less than two years an
international museum has decided to showcase this
incredible body of work. The first time
was for the *Marginalia* exhibition, shown
at the Nouveau Musée National de Monaco,
which I was proud to co-curate with
the groundbreaking museum creator and director
Marie-Claude Beaud.

And now, "la Caixa" Foundation has programmed
a touring exhibition that will travel extensively
throughout Spain, to no fewer than nine art centers.
It is called *Comics, Dreams and History* and presents a
comprehensive exploration of the birth and evolution of
the different kinds of comics born in the western world.
An exhibition on such a scale is a great opportunity
for the public to admire exquisite original drawings,
and discover or re-discover what an important art form
comics are.

That so many masterpieces of comic-book history
should be brought together in the same place is hard to
believe: one would expect it to be the result of decades
of painstaking research by an extensive team. Although
museums have only recently considered these works
worthy of being exhibited, this fascinating collection
was assembled long before the art institutions showed
an interest, and is due to the passion of one man. He
usually stays discreet, but I feel I should override his
modest request for anonymity.

Bernard Mahé has devoted his life to comics, both their conservation and representation. When his passion began, comics were still a marginalized medium, and some art-world actors wondered if he had briefly taken leave of his senses. Nowadays, of course, the financial value of these marvels, serious international recognition, and growing enthusiasm of new generations show how acutely fine-tuned his aesthetic passion has been.

I thank him for his trust in my ability to do justice to his collection.

The majority of the wonderful works you are about to admire were saved and assembled by Bernard Mahé, at a time when many did not consider the originals worth keeping. For many important comic-strip authors, the main prize was publication in the Sunday papers, to be seen by millions of eyes. We are lucky Mahé recognized and succumbed to the beauty of originals.

I hope this exploration will be an occasion for you to succumb, too.

Damien MacDonald
Paris 2022

- I -
TONGUE IN CHEEK
A multilingual birth process

You are about to read an anatomy book about
meta-humans, hybrids, and superheroes. Please beware,
the physical world of comics is whimsical. You might,
in the following chapters, stumble upon hemogoblins,
mermaids, armless monkeys, or she-hulks. But if these
fanciful creatures are scattered throughout, it is not because
the pages of the book were not tidied up before inviting
you in. They are a most active part of the subject you are
about to investigate. This book is more a lover's guide
to the anatomy of comics than a formal dissection. The
body of work is approached with tenderness and caution,
rather than with the surgical knife of scholastic thought.

The aim, however, is definitely not to reduce the ragtag
world of comics to a nicely ordered index of embalmed
organs. Quite the reverse: the art of comics is very much
alive and worth considering as such. Its future looks
marvelous, and the best approach is to dive into its diversity
rather than to catalog it. In that spirit, this anatomy tries
to understand the life process that flows between the
different organic parts of the medium, while drawing
your attention to a selection of its famous originals.

When stepping into the world of comics, one of the first
things to notice is that it is inhabited by a vast array of
surprising creatures. Heroes bulging with protein and
wrapped in spandex (often with more muscles than the
human body can logically contain), travel alongside

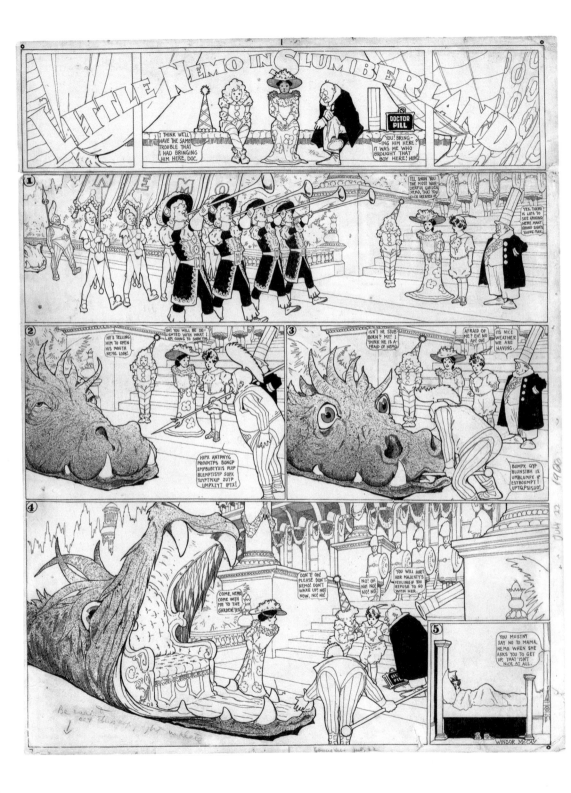

LONG LIVE THE PRINCESS OF SLUMBERLAND

Winsor McCay
c. 1867/71–1937
Little Nemo in Slumberland
(Sunday page)
July 22, 1906

Winsor McCay is a legendary artist. He was the first to draw frame-to-frame animation and to push extensively the boundaries of storytelling in sequential art. He did this by bringing the avant-garde aesthetics of fine art, design, and literature into his creations. Because his exploration of the subconscious is so tender and endearing, with Little Nemo he created a character that immediately became an allegory for the childlike freedom found in early exploration of the psyche. A century later we are still in awe.

hard-boiled detectives in fedoras, emancipated vamps, post-modern zombies, space-opera acrobats in chain-mail underpants, and scrawny underground freaks sustained by a diet of tofu and LSD. This motley crew of characters has grown out of the traditions of Franco-Belgian *bandes dessinées*, American comics, Japanese manga, Italian *fumetti*, and Argentinian and Spanish *historietas*. This constantly mutagenic quality is the comics' first anatomic reality.

The art revels in conjuring up new shapes, working along a mythico-historical framework not unlike that of Ovid's *Metamorphoses*. All the elements of the universe interact. A spider bites a teenager, who then becomes a spider. A young girl antagonizing a bat, in order to protect lone women, will assume the form of a cat. Men emerge from the creative crucible as iron, wolves, or hornets, while a beagle dreams he is fighting the Red Baron. This half-shamanistic, half-psychedelic quality was already seen in 1905, when Winsor McCay invented Slumberland, an eerie kingdom whose princess is courted by the famous daydreamer Little Nemo. But it can also be found earlier, in the canonic works of the Swiss caricaturist Rodolphe Töpffer, often considered the father of comics. Even his early works, like *The Adventures of Mr. Obadiah Oldbuck*, created in 1827 in Geneva, feature heroes that change nature so often they are condemned as sorcerers and sentenced to execution by burning.

Changelings and shape-shifters are built into the fabric of comics and continue today, like with the phenomenal success of Loki, the character inspired by the trickster of Norse mythology. He is originally referred to in the *Poetic Edda* compiled in the thirteenth century from much earlier sources. Loki also reappears in Richard Wagner's *Ring of the Nibelung* cycle, before being invited into the pages of

comics by Stan Lee and Jack Kirby in 1949. The trickster
did so well that in 2014 IGN Entertainment ranked him the
fourth-greatest comic-book villain of all time. Carl Jung
wrote that the trickster is "an archetypal psychic structure
of extreme antiquity. In his clearest manifestations, he
is a faithful reflection of an absolutely undifferentiated
human consciousness." In comics, tricksters often trigger
this type of consciousness at the deepest levels.

But their success alone does not explain why shape-shifters
and changelings are so essential to this medium. Perhaps it is
because, from the very beginning, comic artists themselves
needed to know the tricks of different trades. When
creating sequential art, artists have to explore the skills
of playwrights, caricaturists, scenographers, printmakers,
journalists, illustrators, etc. Thus the founding fathers of
the art experienced the joys and sorrows of multitasking.

Gaspard-Félix Tournachon, known by the pseudonym Nadar,
was one of the first to draw comics, but it was only one of
his many achievements. A brilliant chemist, he paved the
way in the art of photography, inventing aerial picture-
taking. He was also a pioneer in aeronautics, a balloonist,
and a proponent of heavier-than-air flight. As if this were
not enough, he was also a renowned caricaturist, feared
journalist, and novelist. He was not the only polymath
working in comics: the same is true of Töppfer, who had
been a teacher, author, painter, polemicist, cartoonist,
and caricaturist. It can also be said of Wilhelm Busch,
the father of *Max und Moritz*, who was a humorist, poet,
illustrator, and painter, and of Richard F. Outcault, who
invented the Yellow Kid—the first widely recognized
recurring character in the newspaper comics of the mid-
1890s. Before creating his famous street urchin, Outcault
painted electric light displays for Edison Laboratories,

TOOTHLESS STREET URCHIN KICK-STARTS THE YELLOW PRESS

Richard Felton Outcault
1863–1928
The Yellow Kid
September 20, 1869

When Outcault created this bald munchkin living on Hogan alley, he satisfied his contemporaries' cruel desire to laugh at poverty. Fortunately, his creation also gave the street urchin a voice, and made him a superstar. His yellow-shirt/ speech-bubble would become the symbol of sensation-mongering journalism, subsequently dubbed "the yellow press." Despite his incredible success, this comic-strip character—the first to be merchandized—remained on his full-color back page up until 1896, an important year for the Yellow Kid, when he entered the editorial pages.

did mechanical drawings, and supervised the installation of Edison's exhibits at the Exposition Universelle in Paris. This multidisciplinary work probably also helped Outcault in his pioneering developments with the four-color rotary printing press, which allowed him to produce the first comic to feature color. It stands to reason that if their creators had experienced kaleidoscope lives, the characters were going to have multiple identities.

The same can be said for some of the other arts, too. Take early cinema, for example, born at approximately the same time. Frank Capra regularly described in interviews how his first job as a chemist was his ticket into the embryonic world of Hollywood. This is not true of the worlds of literature or the fine arts, which are subject to the rigid codes established by a long line of academies, schools, and institutions. The French Académie Royale de Peinture et de Sculpture was founded in 1648, and the British Royal Academy of Arts in 1768. They in turn were continuing an international tradition established by the guilds and trade corporations. The art of comics in comparison is a newborn, barely more than a century old. Up until the late 1960s, no school, corporation, or guild taught this strange, new, mutant art form. Perhaps Stan Lee and Jack Kirby were in fact fantasizing about a new kind of art education when they depicted their character Charles Francis Xavier founding his famous School for Gifted Youngsters, in which he taught mutants to explore and control their powers, thus creating the original X-Men. In any case, the first creators working in this field were pioneers, often mavericks, jacks-of-all-trades before becoming masters of one. And more than once, they identified with self-taught mutants.

Today the situation has changed, and the art of comics is now the subject of academic study. The first school to ever

teach comics was within the Belgian Écoles Supérieures des Arts Saint-Luc. The institution itself was founded in 1863, but started teaching comics in 1969, approximately a century and a half since the art began. The first teacher was the comic-book creator Eddy Paape. He had worked for the two main Franco-Belgian comic-book magazines (*Spirou* and *Tintin*). After signing books like *Super Gamma-Ray* and *A Machine to Conquer the World*, he was the first person to teach professionally how to draw and write sequential art. Allegedly, the school had been advised to hire him by no less than Hergé and Franquin—impressive recommendations. This course was the first of its kind in Belgium and quite probably the world. It is still running, transformed into a full bachelor's degree. Today, many other institutions around the world teach comics, but up until the 1970s it seemed a crazy idea to commit to creating them, let alone teaching the tricks of such a strange trade. Although today comics have conquered a large section of our culture, up until fairly recently the genre was marginalized, and passion for it was often clandestine. This radical change from an underground, lowbrow medium to being part of mainstream culture has had many surprising consequences, producing changes even in the more conservative world of academia. In 2020, the French Académie des Beaux-Arts elected its first comic-book designer, Catherine Meurisse, a fact celebrated on social media by the French minister of culture. The Collège de France devoted the last few months of 2020 to the medium, with many conferences dedicated to what they called "the genius of comic strips."

These institutions have many qualities, but they are not known for their avant-garde spirit and only a few decades ago their members would not have been caught dead reading comics, let alone those written by a woman. Today, women have an essential part to play in comics,

SKEEZIX, THE ORPHAN OF GASOLINE ALLEY

Frank King, born Frank Oscar King
1883–1969
Gasoline Alley
(Sunday page)
November 6, 1922

With his trademark quiff, Frank King's car-loving bachelor character Walt had a large audience. But the *Tribune* editor, Joseph Patterson, also wanted to attract women readers to *Gasoline Alley*, and thought the best way was by featuring a baby in the comic. As Walt was not married, Frank King conveniently left him a baby on the doorstep. Skeezix had arrived. Gradually the baby started looking like the author's own son, Robert Drew King. Meanwhile, quiff hairstyles would make a serious impact on comics, and King's graphic experimentation would pave the way for many authors.

with major international artists like the Lebanese Marjane Satrapi, the Israeli Rutu Modan, or the American Emil Ferris. But that situation mainly started in the twenty-first century, and the rise of a new type of independent publishing. Sadly, before that, during the period this book covers, most women present in the field were either colorists or considered too frightening for the industry. For instance, June Mills (1912–1988) changed her name to Tarpé Mills so that it was less feminine, but despite that, her voluptuous, free-spirited heroin Miss Fury was censored in 1947 by thirty-seven newspapers because of the vivacity of her whips and lingerie scenes. Fantagraphics did great work on the question of the far-too-slow liberation process with their *Complete Wimmen's Comix.*

Nevertheless, gradually, the art has conquered important conservative bastions. Franquin's original drawings used to be discarded on the floor of the printers, left to be trampled underfoot, while authors of comics hid behind pseudonyms. In December 1948, hundreds of children were photographed by *Time* magazine standing around piles of burning comics in order to purge their souls from the foul influences of cartoons. These exorcisms appeared regularly throughout the United States, under the influence of psychiatrist Fredric Wertham, author of the polemical pamphlet against comics: *Seduction of the Innocent.* Wertham seemed to suffer from a kind of delirium in 1954, daring to say before the Senate hearing on juvenile delinquency: "I think Hitler was a beginner compared to the comic-book industry. They get the children much younger." The art, it can be said, faced slight prejudice.

Luckily, times have changed and the profession is gradually gaining respect. At the time of writing, an extensive exhibition is about to tour nine art centers in Spain, showing

once again how the attitude of cultural institutions has changed. But despite the growth in formal teaching, most authors, when asked, declared that they really learnt their professional skills by working in the studio with other artists, or by imitating the artists that came before them. So, at least until the 1970s, and probably still today, comic-book authors were prone to having multiple careers and identities, being necessarily self-taught, and often having to juggle between day-jobs. Alan Moore put it nicely:

> I've never studied anything formally.
> I was excluded from school at the age
> of seventeen, so I am an autodidact.
> Which is a word that I have taught myself.

Perhaps because of this, this very young art form tended to recreate fraternal studio work-patterns, not unlike those of the ancient guilds, at least in the United States. (This is not necessarily true of European comics, since the importance of studios is less prevalent today.) In the United States, it is rare to see a comic book signed by fewer than three or four artists. Putting aside the spandex costumes and the industry's set of rules, this cooperative artwork and mythological creativity has something medieval about it, the kind of work structure that would have appealed to socialist designer William Morris, whose ideas inspired the creation of the Art Workers' Guild in 1884. Perhaps, in years to come, comic-book artists will see the social advantages of cooperative working, and will be able to create outside of corporate restrictions.

This autodidacticism has had a lasting effect on the stories that comics tell. Superheroes, and other types of heroes, have hidden identities, just like their authors with their tradition of using pseudonyms. Changing names was even

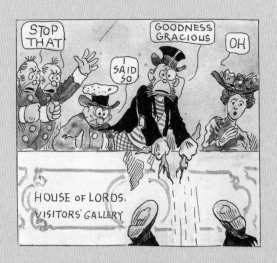

THE DUKE OF HOOLIGANS

Frederick Burr Opper
1857–1937
Happy Hooligan
April 9, 1905

The Great Depression saw the rise of the screwball comedy,
with its cheerful critique of social class. But decades before
then, Opper's Happy Hooligan fascinated readers with his
lighthearted approach to poverty, his hobo smile, and his
absurdist puns, qualities which are said to have inspired
Chaplin. In this iconic strip the famous Hooligan visits the
House of Lords but ends up locked in the Tower of London.
Being an aristocratic hobo makes Happy
a kind of prequel to the beatniks.

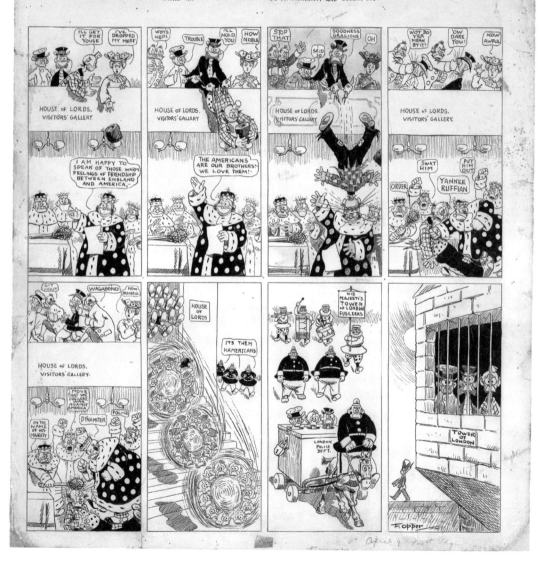

 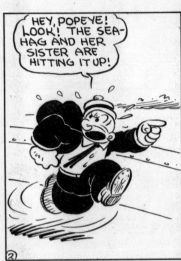 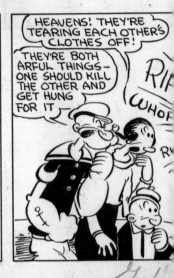

3-5 152

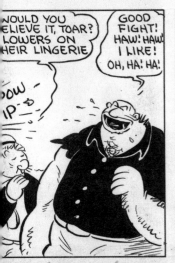

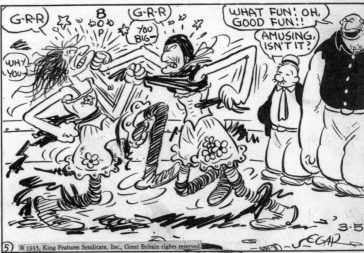

SEAHAGS' LINGERIE AND SPIRITED SAILORS

Elzie Crisler Segar
1894–1938

Popeye
(daily strip)
March 5, 1935

Today, Popeye's fame has outgrown his author's, but Segar's story was one of self-made success and the surprising side-effects of spinach. After creating a daily gag for *Charlie Chaplin's Comic Capers*, Segar invented his boisterous one-eyed sailor and the rest of his *Thimble Theater* cast, providing inspiration for generations of kids, but also authors like Charles M. Schulz. After Segar's untimely death, the show needed to go on, so King Features Syndicate used this precise strip to teach future illustrators how to capture all the magic of the famous character.

something of an obsession for great artists, as with Will Eisner at the beginning of his career. As Tom Heintjes points out in his essay "The Spirit: The Origin Years":

> Eisner used them with gusto, incorporating into his work such imaginative noms de plume as Mr. Heck, Willis B. Rensie ("Eisner" spelled backwards), W. Morgan Thomas (used on Mr. Mystic), Erwin Willis, Wm. Erwin, and a host of others.

Nearly all the artists in the famed Eisner-Iger studio used pen names, the reasons for which have been discussed at length. Many of these authors were Jewish and may have wanted to keep that information to themselves. They had had first-hand experience of the violent waves of antisemitism pre-World War II, and found resilience in creating superheroes that would fight fascism while showing the dangers of American isolationism. But it was not the only reason, as Jeremy Dauber in his book *American Comics* explains:

> In his later autobiographical account, one creator asks another why he changed his name. "Goin' to have my own daily strip one day!!" the other replies. "Y'need a classy name to get ahead!"

Dauber shows that the use of pseudonyms was probably more about hiding their art than their origins. After all, Europe witnessed the same flourishing of pseudonyms among comics authors who were not immigrants, and who sometimes even worked within very conservative institutions (Hergé, for example, did not sign his work Remi Georges).

Comics being considered lowbrow and commercial, artists
shied away from claiming authorship, creating for them
a kind of double life that parallels the double life of the
superhero. Today we readily accept the dual identity of
superheros—what Umberto Eco calls a "brilliant mytho-
poetic discovery"—and such identification with the dual
or multiple identities of these supermen redeems our own
mediocrity. Yet, this "mytho-poetic" invention grew out of
the struggle with the inglorious aspects of the comic art.
As many authors were ashamed of being identified with
the penny dreadful and the pulp novel, the purpose of the
pseudonym was concealment, rather than the pleasure it
was for the great Portuguese poet Pessoa with his roll call of
"heteronyms." It was more a necessary social shyness created
by the popularity of the medium. However, this considerably
enhanced the metamorphic quality of comic-book stories
and the never-ending score of hybrids with uncanny powers.
And it had another important effect. Today, many people
have multiple online avatars. Indeed, the Sanskrit word
avatar, originally used to describe the multiple incarnations
of deities in Hinduism, is today very common. Comics were
quite a few years ahead in addressing this concept, and
helped us grapple with the idea of a many-faced identity.

The fantasy of humans mingling with nature is another
aspect of comics that appeals to the contemporary
"Anthropocene" mind. Many of us yearn for a better
connection to nature. Ancient mythology hosted a whole
cast of characters that changed into beasts, trees, seas,
or winds, but they disappeared with the more scientific
worldview prominent today. Comics brought them back,
center stage. The human soul was slightly homesick
and missed its metamorphic relation to the elements,
yearning for this interrelated universe. Cutting up the
world into pieces in order to decode it—from elementary

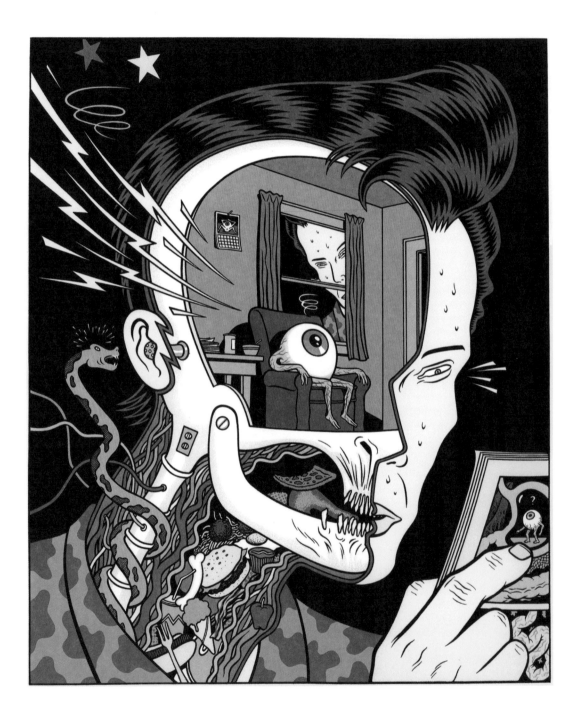

ANATOMY OF COMICS

Charles Burns
b. 1955
Métal Hurlant
Issue #120 (cover)
1986

This illustration, also used as the cover of this book, is by the legendary artist Charles Burns. It was first a silkscreen print published in a limited edition by l'A.P.A.A.R. in 1985 and printed by Frédéric de Broutelles. Since then, it has been used as a cover for iconic magazines like *Métal Hurlant*, *Juxtapoz*, and *El Vibora*. Its first use as a cover was on *Dope Comix* #5, in which the main character is not reading a comic but smoking a joint, which then leads to his indulging in far more potent drugs: comics. The transition between the two drawings lets us understand how comicbook art can be a portal into new mindscapes, literally an eye opener. Charles Burns once said: "I try to achieve something that's almost like a visceral effect. The quality of the lines and the density of the black take on a character of their own—it's something that has an effect on your subconscious. Those lines make you feel a certain way."

particles to the first human genome sequences of 2001—
has been an essential step in our evolution, but during
this process of "cutting-up" something was forgotten
about interdependence. This rediscovered energy, which
travels from animal to human and back, is part of the
success story of comics, since our planet has never before
been so fragile, and humans so cut off from nature. In
comics, it is absolutely impossible for the fickle elements
of reality to stay obediently in their different categories.
This instability, and the fact that anybody can shape-
shift just when you were looking the other way, has
been an element of this kind of storytelling from the
start of its tangled origins. In Alan Moore's *Promethea*
series, the heroine is warned: " Listen kid, you take my
advice. You don't wanna go looking for folklore. And you
especially don't want folklore to come looking for you."
Promethea is then caught up by folklore, and splinters
into a whole range of previous historical personalities.
Myths and folklore are, notoriously, alive in this art form,
and a wild energy flows through the fabric of our world,
which can touch even the poor and outcast, turning them
into mutants. For this reason, this anatomy of comics will
try to function in a holistic way, and not chop the body
of work into sadly disconnected parts. When speaking of
mutants, one immediately thinks of Professor Xavier, but
also of Timothy Leary, the pope of LSD, who once wrote:

> I declare that the Beatles are mutants. Prototypes
> of evolutionary agents sent by God, endowed
> with a mysterious power to create a new human
> species, a young race of laughing free men.

This interconnected mindscape is familiar to most comic-
book readers. It draws on the heritage of fairy tales and
folklore, using the natural animism of children as a fertilizer,
but this awe-inspiring quality also has another, deeper

origin story. And this starts with the tongue, and language. In contemporary works the mutating body is a recurring theme, in which animals, plants, stardust, and nuclear energy play an active metamorphic part. This book's cover artist, Charles Burns, is notorious for using these original elements. For instance, in his *Black Hole* series— which the *New York Times* described as a "world-warping chaos of youth and sex"—the bodies of teenagers literally shed their skins and grow weird, small, sex-like, animal tails. The reader follows these disaffected suburban teens of the 1970s through thick black ink and equally dark forests of the soul, during a very peculiar "sex, drugs, and gloominess" experience. The psychic pains of the heroes evolve into very different anatomical forms. Burns is one of the artists who has gone furthest in drawing fanciful anatomies. Unexplained open wounds burgeon with inner metastasis; regular molting of skin shows us that we can always get more naked. By unleashing these creatures, Burns incorporated a post-beatnik philosophy to the interconnected mindscape of comics. Burns seems to believe, like William Burroughs used to say, that language itself is a virus. The gentleman junkie famously wrote in *The Ticket That Exploded*:

> The word is now a virus. The flu virus may have once been a healthy lung cell. It is now a parasitic organism that invades and damages the lungs. The word may once have been a healthy neural cell. It is now a parasitic organism that invades and damages the central nervous system. Modern man has lost the option of silence. Try halting sub-vocal speech. Try to achieve even ten seconds of inner silence. You will encounter a resisting organism that forces you to talk. That organism is the word.

THE KAT FROM COCONINO
LOVED BRICKS

George Herriman
1880–1944
Krazy Kat
September 9, 1933

Krazy Kat lives in Hopi territory in the county of Coconino.
He thinks the bricks thrown at his head by Ignatz the
mouse are love letters. Officer Pupp's unrequited love for
Krazy makes him want to throw Ignatz in jail. These little
animals are the totemic creatures that presided at the birth
of comics. Herriman's work has been described as "more
influential than popular," with the iconic, gender-fluid Kat
the hidden muse beloved by most comic-book creators.
Meanwhile, the Kat mainly loves bricks.

Comics are clearly working with that viral organism called language, which mutates and permeates the drawings. How better to define the use of words that has emerged from writing in this medium?

The first body of work took shape in a surprising amniotic fluid made of many tongues, a cocktail of multiple languages. It is no coincidence that the early artists contributing to the new language of comics were very often from multilingual families. This creolization of cultures, this meeting of different tongues, is an essential anatomic peculiarity of comics.

At the beginning of World War I, George Herriman created his famous Krazy Kat for the *New York Evening Journal.* Poet E.E. Cummings called Krazy "the only original and authentic revolutionary protagonist." This gender-fluid cat is in love with a mouse and speaks a mixture of Yiddish, Spanish, French, and American slang. This idioglossia (an idiom spoken by only one person) had a ferocious reader called James Joyce, and might even have inspired some of the ingredients that went into the idiosyncratic language of *Finnegans Wake.* Krazy Kat's habit of ridiculing prisons and the police makes him a true ancestor of the cult cats of the American underground comics of the 1960s and 70s: Fritz the Cat, invented by Robert Crumb, or Fat Freddy's Cat, the turbulent pet of Gilbert Shelton's Freak Brothers.

Krazy Kat is not the only comic for which this is true. Rudolph Dirk's Katzenjammer Kids also have a way of mixing their native German with American culture and making it evolve in a fantasized Africa, while the Yellow Kid from Hogan Alley speaks such an exaggerated New York gang-war slang that it becomes a new language. These are just a few of the characters who invented their own jargon.

The Tower of Babel of American immigration has found in this art a way of combining drawing and text, but also language and infra-language. Just as the Belgian Smurfs invented an idiom, throughout the twentieth century the comic emerged as a territory for verbal experimentation, from the Katzenjammer Kids to Alan Moore's *Jerusalem*.

This had a profound impact on the creation of contemporary global culture. Jeremy Dauber writes in his book *American Comics*:

> Immigrant readers were of particular interest to publishers; numerous and disproportionately urban, thus a more concentrated consumer base, their pennies and nickels were as good as anyone else's. Their nonnative English, though, often rendered a product composed mostly of English words a hard sell. One solution: take advantage of America's required public school education and develop features attractive to immigrants' children—native or near-native English speakers who would prevail upon their parents to buy a favored newspaper.

The product that met this demand, and was pushed forward at this point, was the comic. Thus this metamorphic counterculture was also born because the new medium helped immigrants learn the language and social codes of the United States. The mixing of tongues played an essential part in the birth of comics, and speech bubbles are a fusion of multiple visual and verbal languages.

PREDICTING TELEVISION IN THE NINETEENTH CENTURY

Albert Robida
1848–1926
The Flying Machine
(illustration)

Nobody knows how Albert Robida could see so far into the future. Unfairly forgotten after World War I, this compulsive illustrator is a lucid and shiny beacon of hope in the shadows of dreamworld. His sense of wonder allowed him to invent machines that make Elon Musk's Hyperloop look old-fashioned. He is said to have conjured up sixty thousand drawings and foreshadowed the wild imaginings of the likes of Philip K. Dick. Comics' imaginary landscapes owe this founding father a great debt.

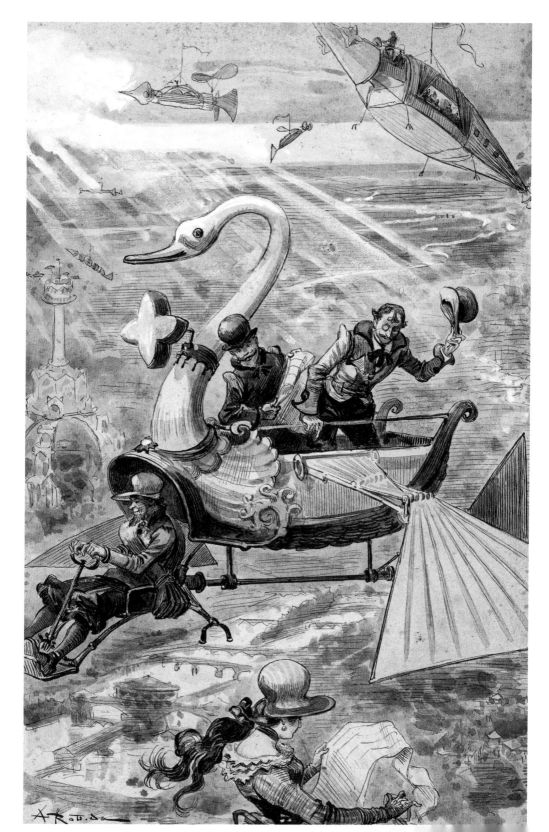

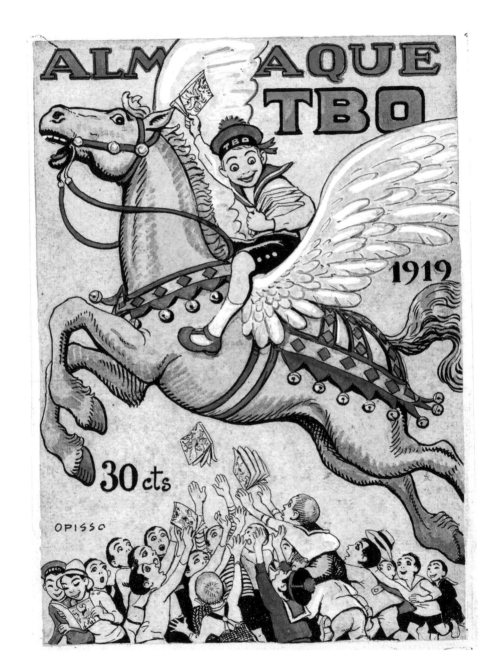

GAUDI, PICASSO, AND COMICS— MODERNIST CATALONIA

Ricard Opisso Sala
1880–1966
Almanaque TBO
(cover)
1919

The Four Cats was the name of the place— *Els Quatre Gats* in Catalan. It became the haunt of the journalist, historian, critic, and comic-book artist Ricard Opisso Sala, along with a new crowd of modernists and bohemians. There he started drinking with Picasso, assisting Antonio Gaudí with the Sagrada Família, and drawing comics.

A COLONIALIST FOUNDING FATHER

Alain Saint-Ogan
1895–1974

Saint-Ogan's characters
(illustration)
July 5, 1938

When Queen Elizabeth was twelve years old, and her sister
Margaret was eight, they received this present by Alain
Saint-Ogan, one of the pioneers of comics. This was not the
only link between the Windsors and sequential art, since
Edward VIII considered Hal Foster's *Prince Valiant*
to be the "greatest contribution to English literature in the
past hundred years." Saint-Ogan's very colonialist view of
the world would probably have appealed to the Windsor's
worldview in 1938, but is now very outdated. Nonetheless, he
contributed greatly to the development of narrative layouts.

Réplique par ALAIN DE SAINT-OGAN d'une page
de l'album offert par le Gouvernement Français
à L.L.A.R. les Petites Princesses d'Angleterre
à l'occasion de la réception en France de L.L.M. Georges VI
Roi d'Angleterre et la Reine Elisabeth.
~ PARIS ~ 5 Juillet 1938 ~

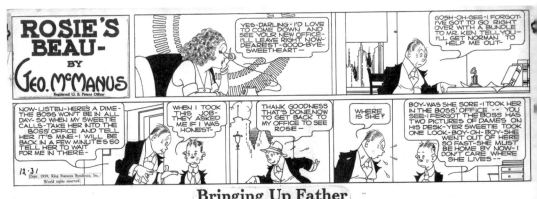

IT'S HARD TO BRING UP PARENTS

George McManus
1884–1954
Rosie's Beau and *Bringing Up Father*
(Sunday page)
December 31, 1939

Just because Jiggs and his creator smoked the same cigars,
sported the same hat, were Irish immigrant pranksters who
went from rags to riches, and shared the same expanding
waistline, some art critics assumed this famous comedy
was slightly autobiographic. But *Bringing Up Father* is full of
inventions: McManus's hypermodern use of vivid outlines
made his characters seem to dance and their emotions
burst from the page. This earned its author
twelve million dollars and a mischievous grin.

© 1929, Edgar Rice Burroughs, Inc. — Produced by Famous Books and Plays
DISTRIBUTED SOLELY BY UNITED FEATURE SYNDICATE, Inc.

Tarzan

by EDGAR RICE BURROUGHS

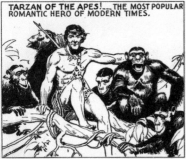

TARZAN OF THE APES!.... THE MOST POPULAR ROMANTIC HERO OF MODERN TIMES.

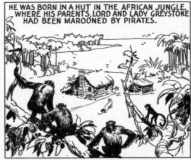

HE WAS BORN IN A HUT IN THE AFRICAN JUNGLE, WHERE HIS PARENTS, LORD AND LADY GREYSTOKE, HAD BEEN MAROONED BY PIRATES.

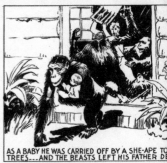

AS A BABY HE WAS CARRIED OFF BY A SHE-APE TO THE TREES... AND THE BEASTS LEFT HIS FATHER DE

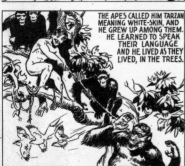

THE APES CALLED HIM TARZAN MEANING WHITE-SKIN, AND HE GREW UP AMONG THEM. HE LEARNED TO SPEAK THEIR LANGUAGE AND HE LIVED AS THEY LIVED, IN THE TREES.

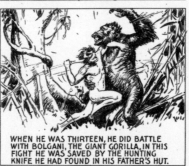

WHEN HE WAS THIRTEEN, HE DID BATTLE WITH BOLGANI, THE GIANT GORILLA, IN THIS FIGHT HE WAS SAVED BY THE HUNTING KNIFE HE HAD FOUND IN HIS FATHER'S HUT.

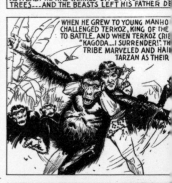

WHEN HE GREW TO YOUNG MANHOOD CHALLENGED TERKOZ, KING OF THE TO BATTLE. AND WHEN TERKOZ CRIE "KAGODA...I SURRENDER!" THE TRIBE MARVELED AND HAIL TARZAN AS THEIR

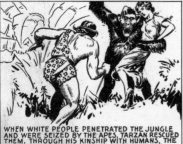

WHEN WHITE PEOPLE PENETRATED THE JUNGLE AND WERE SEIZED BY THE APES, TARZAN RESCUED THEM. THROUGH HIS KINSHIP WITH HUMANS, THE APE-MAN WAS PERSUADED TO GO BACK TO THE LAND OF HIS FATHERS.

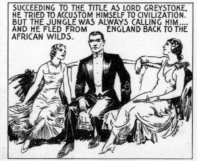

SUCCEEDING TO THE TITLE AS LORD GREYSTOKE, HE TRIED TO ACCUSTOM HIMSELF TO CIVILIZATION. BUT THE JUNGLE WAS ALWAYS CALLING HIM.... AND HE FLED FROM ENGLAND BACK TO THE AFRICAN WILDS.

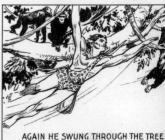

AGAIN HE SWUNG THROUGH THE TREE WITH THE GAY FREEDOM OF HIS BROTHE THE APES.

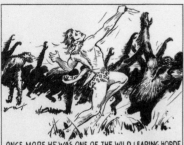

ONCE MORE HE WAS ONE OF THE WILD LEAPING HORDE IN THE MAD DEATH DANCE OF THE DUM-DUM.

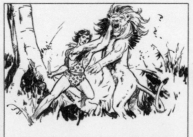

WHEN HE KILLED NUMA, KING OF THE BEASTS, HE WAS HAILED AS LORD OF THE JUNGLE.

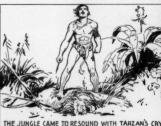

THE JUNGLE CAME TO RESOUND WITH TARZAN'S CRY MAD VICTOR CRY OF THE BULL-APE AT THE KILL-- EVER-ONWARD HE WENT, THROUGH STRANGE FAR-O COUNTRIES, FILLING HIS LIFE WITH THE WILD JOY OF GLING ADVENTUREWATCH FOR THE NEW ADVENTUR OF TARZAN.

THE JUNGLE'S GENTLEMAN

Hal Foster, born Harold Rudolf Foster
1892–1982
Tarzan
(Sunday page)
1933

Gore Vidal defined him as "an archetype American dreamer," Kipling called him a genius, and the *New York Times* said he was "plagued by mysterious illnesses and continued nightmares, defensively abrasive concerning his status as a 'popular' writer.'" After unsuccessful careers as a cowboy and a gold-dredge worker, Edgar Rice Burroughs created one of the most popular modern legends: *Tarzan*. The Jungle's Gentleman was such a success he got his own comic, for which Hal Foster produced some of the iconic imagery that would change modern visions of masculinity.

HOKUSAI MEETS TARZAN

Burne Hogarth
1911–1996
Tarzan: The Deluge Strikes
(Sunday page)
March 23, 1941

Burne Hogarth, the celebrated illustrator of *Tarzan*, also
wrote books on how to draw human anatomy, a subject he
taught extensively. His passion for baroque art, and what
Baudrillard named its "vortex of artifice," is well known, but
his influence for this particular drawing is quite different.
This was first shown at the Museum of Decorative Arts in
Paris in 1967, and it has since toured many others. Here,
Hogarth has clearly taken the time to admire Eastern art,
and, more specifically, the way the Japanese
genius Hokusai taught the world to draw waves.

Tarzan

THE DELUGE STRIKES

by EDGAR RICE BURROUGHS

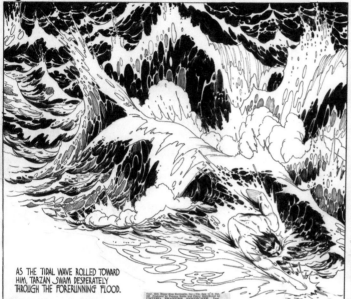

AS THE TIDAL WAVE ROLLED TOWARD HIM, TARZAN SWAM DESPERATELY THROUGH THE FORERUNNING FLOOD.

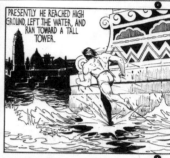

PRESENTLY HE REACHED HIGH GROUND, LEFT THE WATER, AND RAN TOWARD A TALL TOWER.

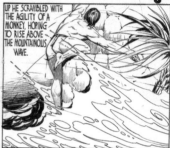

UP HE SCRAMBLED WITH THE AGILITY OF A MONKEY, HOPING TO RISE ABOVE THE MOUNTAINOUS WAVE.

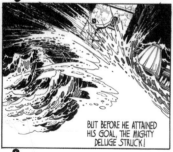

BUT BEFORE HE ATTAINED HIS GOAL, THE MIGHTY DELUGE STRUCK!

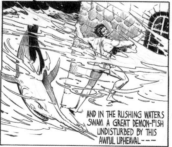

AND IN THE RUSHING WATERS SWAM A GREAT DEMON-FISH UNDISTURBED BY THIS AWFUL UPHEAVAL---

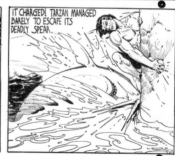

IT CHARGED! TARZAN MANAGED BARELY TO ESCAPE ITS DEADLY SPEAR.

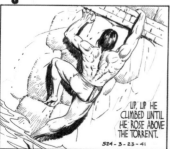

UP, UP HE CLIMBED UNTIL HE ROSE ABOVE THE TORRENT.

524-3-23-41

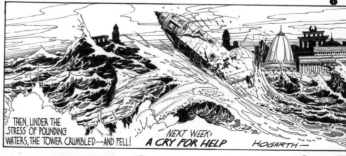

THEN, UNDER THE STRESS OF POUNDING WATERS, THE TOWER CRUMBLED--AND FELL!

NEXT WEEK: A CRY FOR HELP

HOGARTH

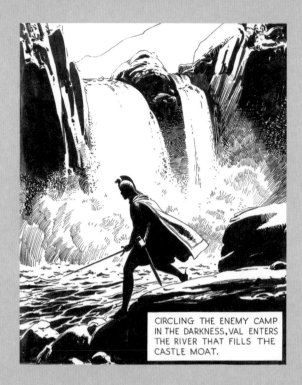

CIRCLING THE ENEMY CAMP IN THE DARKNESS, VAL ENTERS THE RIVER THAT FILLS THE CASTLE MOAT.

HOW W.R. HEARST FINANCED THE QUEST FOR THE HOLY GRAIL

Hal Foster, born Harold Rudolf Foster
1892–1982
Prince Valiant
(Sunday page)
May 28, 1939

For most comic-book authors who came after him, Hal Foster's mind-blowing draftsmanship is the equivalent of Prince Valiant's quest for the Holy Grail. Among all the elements that are difficult to draw—water, fire, architecture, action scenes—none escapes his bewildering mastery. Apart from the prince's tacky haircut, the strip is esthetically flawless. William Randolph Hearst, who employed Foster and, surprisingly, left him ownership of the strip, thus financed the twentieth-century quest for the comic-book artist's Grail.

Prince Valiant

IN THE DAYS OF
KING ARTHUR
BY
HAROLD R FOSTER

ATTILA

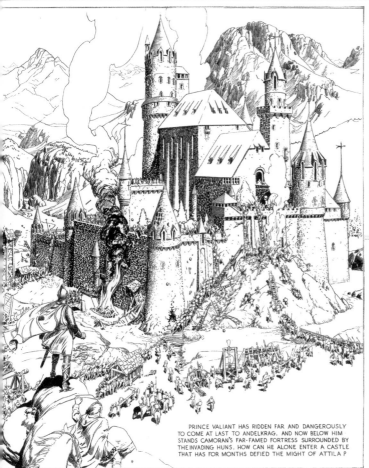

PRINCE VALIANT HAS RIDDEN FAR AND DANGEROUSLY TO COME AT LAST TO ANDELKRAG. AND NOW BELOW HIM STANDS CAMORAN'S FAR-FAMED FORTRESS SURROUNDED BY THE INVADING HUNS. HOW CAN HE ALONE ENTER A CASTLE THAT HAS FOR MONTHS DEFIED THE MIGHT OF ATTILA ?

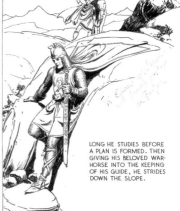

LONG HE STUDIES BEFORE A PLAN IS FORMED. THEN GIVING HIS BELOVED WAR-HORSE INTO THE KEEPING OF HIS GUIDE, HE STRIDES DOWN THE SLOPE.

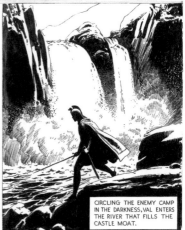

CIRCLING THE ENEMY CAMP IN THE DARKNESS, VAL ENTERS THE RIVER THAT FILLS THE CASTLE MOAT.

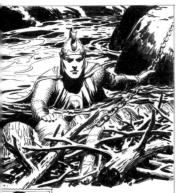

HE HAS ALMOST REACHED THE MOAT WHEN HIS WAY IS BARRED BY A RAFT PILED HIGH WITH FUEL.

CAMORAN

120 - 5 - 28 - 39

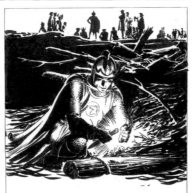

IT IS A FIRE-RAFT WITH WHICH, ON THE MORROW, THE HUNS HOPE TO BURN AWAY THE DRAW-BRIDGE AND GATE OF ANDELKRAG. WITH FLINT AND STEEL

...VAL DESTROYS THEIR WORK. "TREACHERY", THEY CRY AND SEARCH FIERCELY FOR THE CULPRIT!

HAL FOSTER

NEXT WEEK :
CAMORAN

ATTILA'S
ROMAN BRIDE

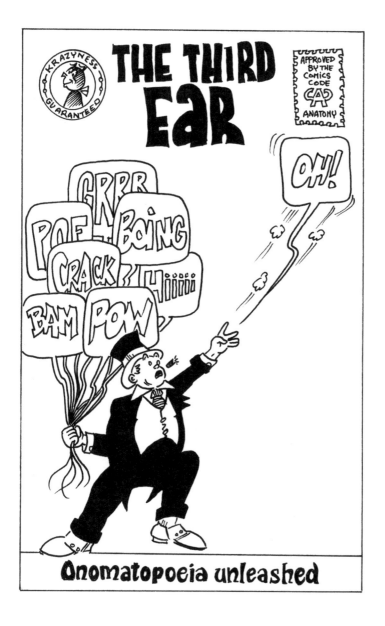

- II -
THE
THIRD EAR
*Onomatopoeia
unleashed*

Readers of *Finnegans Wake* will remember Joyce's musicality.
His stream-of-consciousness, linguistic experiments
have a visual counterpart in the free, dream associations
of comic-book art.

Music is so essential to the comic artist's work that one
can almost classify comics according to the music their
authors draw to. Robert Crumb is famously passionate about
syncopated blues musicians like Blind Boy Fuller, singer
of "Truckin' my Blues Away." With his band, the Cheap Suit
Serenaders, Crumb has, for half a century, explored a catalog
of 1920s-inspired ragtime and classic jazz standards.
He is often thought to be a fan of Janis Joplin, as he drew
the famous cover for Big Brother and the Holding
Company's 1968 album *Cheap Thrills*, but this is a
misunderstanding. As he has explained, Janis Joplin's
music is far from his favorite. A closer look at Crumb's
"syncopated" drawings clearly shows he is more akin to
the old-timer's banjo than to the hyper-saturated electric
guitar James Gurley played in a self-described "far-out"
acid-rock style on Joplin's album. Maybe the only song
on *Cheap Thrills* that could be considered to resonate
with Crumb's drawings is the track "Turtle Blues."
Despite Crumb's preferences, the psychedelic electric guitar
was far from foreign to the realm of comics.
It played an essential part in the creativity of the
founders of the iconic French magazine *Heavy Metal*,

TIME, SPIRIT, AND SPACE

Will Eisner, born William Erwin Eisner
1907–1988
Wally Wood, born Wallace Allan Wood
1927–1981
***The Spirit
Mission... The Moon***
(cover)
August 3, 1952

When he was twenty-five, Wally Wood drew for Will Eisner on the Spirit's Sunday supplement, a mythical collaboration which produced this drawing from The Spirit in *Outer Space*. Together, the wacky wonder kid and Eisner, the father of graphic novels, created an important aspect of the Spirit. When Wally Wood drew his self-portrait he asked: "Did you know that there are other worlds that co-exist with ours... That there are people passing thru you right now, existing on another plane... " That's probably what drawing allows: spirits passing through us.

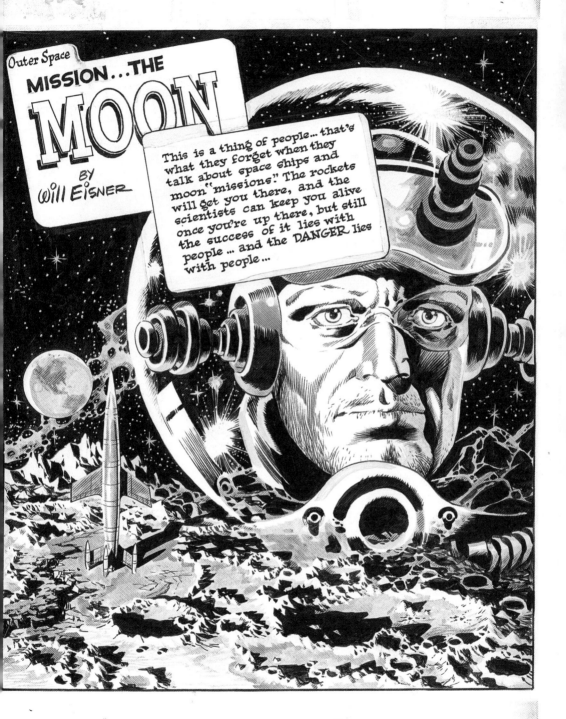

I was a frustrated writer, a frustrated painter … And here, for the first time, was this marvelous opportunity that happens to any creative person once in a lifetime. Suddenly, there appears a medium, a receptacle, that takes your inaptitudes in both fields, puts them together, and comes out with an aptitude.

Will Eisner

THE BIRTH OF
THE GRAPHIC NOVEL

Will Eisner
1917–2005

Contract with God Trilogy: Life on Dropsie Avenue
(cover)
1994

Will Eisner laid the foundations for comics. He was the
first to use the term "graphic novel," and never hesitated to
address important themes such as the origins of conspiracy
theories. In his heartbreaking *Contract with God Trilogy*,
subtitled *Life on Dropsie Avenue*, Eisner follows the life of a
specific building, 55 Dropsie Avenue, for nearly a century,
starting in 1870. This panorama is not only historically
fascinating and sociologically accurate,
but also exquisitely poetic.

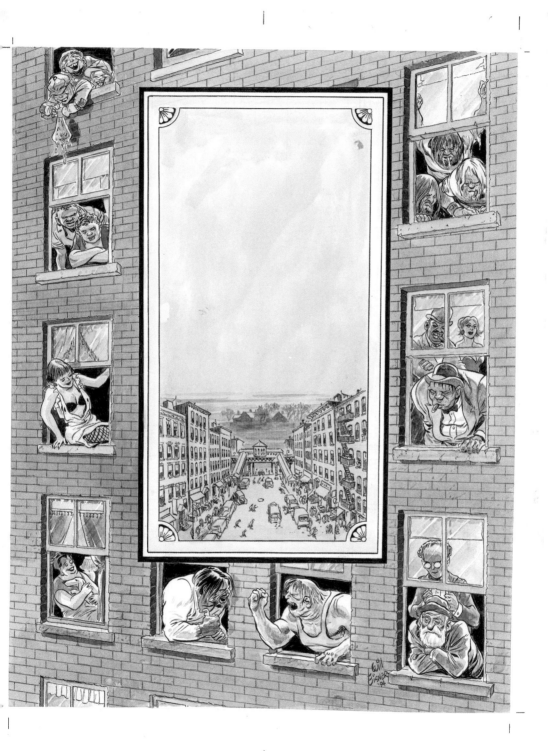

especially Mœbius and Druillet, who both drew covers
for Jimi Hendrix albums. Mœbius has said how he often
listened to the repetitive music of artists like Terry Riley,
Steve Reich, and Philip Glass. His hatching and cross-
hatching display a parallel quest for the conjunction of
repetition and minimalism. It has become something
of a tradition for musicians and comic-book artists to
collaborate, which has provided some great moments,
such as when Gilbert Shelton drew for the Grateful Dead,
Liberatore for Frank Zappa, or Frazetta for Meat Loaf.

But beyond this link between the lifestyle of the artists
and their equivalent in the music world, there is another
intrinsic relationship between comics and musicality. The
way stories are divided into boxes and speech bubbles
creates a rhythm, a pitch, and even a melody, as Will
Eisner described in a conversation with Jerry De Fuccio in
1976 about his comic *The Spirit*. Will Eisner was a pioneer
in shaping the medium, as Neil Gaiman described:

> Will's life is, in miniature, a history of American
> comics. He was one of the very first people to
> run a studio making commercial comic books,
> but while his contemporaries dreamed of getting
> out of that ghetto and into more lucrative and
> respectable places—advertising, perhaps, or
> illustration, or even fine art—Will had no desire
> to escape. He was trying to create an art form.

When *The Spirit* first appeared in 1940, America had not
yet entered World War II, the atom bomb was still in the
future, and Eisner decided to give rise to a new art form
using this strange cultural ghetto as his raw material. Eisner
was also the first to use the term "graphic novel," and later
did not hesitate to address themes as important as his
experience of the Vietnam War, grief and mourning, and

the everyday life of immigrants. Today, the most important award a comic-book author can receive in the United States is called an Eisner award, and that is not for nothing.

This is how Eisner spoke about musicality in that conversation with De Fuccio:

> De Fuccio: Your writing in *The Spirit* is full of the exhilaration of sounds that move: "Down from the mountains of madness, through the gorges of greed, flows the river of crime …!" I think that's called personification, right? How do you judge when a sequence is "writing itself" to your complete satisfaction? And how often has a sequence taken a fortuitous turn that you hadn't even planned?
>
> Eisner: I write in onomatopoeia, which relies on instinct rather than just the conscious mind. Most of my writing is done by sound and visual. I think of words and narrative as the "sound track." As with all art, "serendipity" is a part of the process. I generally start with a premise … a doorknob if you will, and I proceed to build a house around it.

It is almost impossible to overestimate the importance of what Eisner says here. His art revolves around drawn sounds. The fact that language becomes an instinctive soundtrack around which the story is built, is not only a very poetic way of thinking, it is also an exceedingly efficient work process that has influenced the genesis of the art. Writing and thinking in onomatopoeia is not something that comes naturally in Western culture. Since ideograms are already a fusion of drawing and language, the use of drawn sounds often seems more fluid and accurate

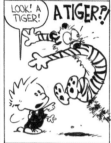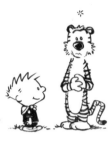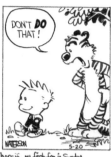

SCHIZOID TOY TIGERS

Bill Watterson
b. 1958
Calvin and Hobbes
(daily strip)
May 20, 1986

The title of *Calvin and Hobbes* is deceptive. It is not exactly about the sixteenth-century theologian of predestination and the seventeenth-century philosopher who said, "Curiosity is the lust of the mind." It is also about a little boy with a healthy imagination and his half-toy, half-real pet tiger, living in a world that tends to belittle imaginary feats. In his *Short, Tongue-in-Cheek Autobiography*, the brilliant author explained: "Disillusioned, Watterson turned to comic strips. The next few years were not proud ones, and only a well-tuned, used Fiat kept Watterson from the law's grasp."

in Japanese manga, and in Asian art generally, but in the West the idea of differentiating between language and drawing is deeply inbuilt. Young people wanting to learn how to draw are given books like Betty Edwards' *Drawing on the Right Side of the Brain*, which assumes language and drawing belong to different parts of the cerebral cortex, as though the pen is telling the paintbrush, "we don't live in the same world." But comics draw language, and by doing so are bridging a gap, just as they bridge the gap between the underground and the mainstream, between popular culture and progressive imagination. When language and drawing are brought together, the first result is music. After all, when William Blake started engraving his poems and their illustrations on the same copper plate, they quite naturally became the songs of experience.

If comics began to appear approximately half-way through the nineteenth century, it is probably because we were only just starting to use visual information as actual information. Edward R. Tufte, in his book *The Visual Display of Quantitative Information*, explains:

> The use of abstract, non-representational pictures to show numbers is a surprisingly recent invention, perhaps because of the diversity of skills it requires—the visual-artistic, empirical-statistic, and mathematical. It was not until the 1750–1800 that statistical graphics … were invented."

It may come as a surprise that drawings were not used to display quantitative information long before, but in the West we used to believe firmly in separating language and image. It has been fashionable for centuries to divide imagination on one side and reason on the other, but once reason began to use images to communicate information,

and pictures became easier to print, and even photography contributed to the evolution of reproduction, comics were quite logically on their way to creating a new way of thinking. The fact that Nadar was a pioneer in both photography and comics speaks volumes on the relationship between technological reproduction and the nature of the art of the comic. If graphs were born to communicate quantitative information visually, comics seem to share on an industrial scale a visual display of musical thought.

"I write in onomatopoeia." Eisner's sentence could have been said by most committed comic-book authors, which does not mean they lack serious thinking. In his book *Fluid Concepts and Creative Analogies*, Douglas Hofstadter says that "ambiguity and context-dependence are pervasive in music, and moreover are central to the way that music carries meaning." Clearly the metamorphic qualities explored earlier resonate here.

"*I write in onomatopoeia.*" Most great changes in the human mind came from unexpected cocktails. Let us remember Hogarth's Prince Valiant, and note that the ethics of knighthood were a strange mixture of the ideals of Christianity and the hierarchical passions of warriors. These two worlds should not have logically coexisted, since Christianity forbids killing, and warriors tend to kill. Yet this unlikely cocktail created the main energy of medieval times and the idea of a quest for the Holy Grail, around which Western civilization and its comics still revolve. In a similar fashion, the birth of the scientific mind dates back to the Renaissance, and was born out of the strange combination of hermetic thought and mechanical research, bringing together the magus and the mechanic—another unlikely cocktail, which a great number of science fiction comics have beautifully developed. It might sound romantic, but comics are themselves another of these strange cocktails

that mix two thought processes: drawing and writing, the visual and the analytical. Comics as a mixture of literary analysis and visual knowledge represent an artistic revolution still to come. The brilliant philosopher Michel Serres, when he was writing about Hergé's work, said: "Here is the secret of metamorphosis: the stochastic mixture."

"*I write in onomatopoeia,*" could be a motto for comics, a way to make visual sense of ambiguity and context-dependence, a way of creating stories out of the rhythm that divides the page, bringing language and drawing back together, after being forced out of wedlock by dualism. Maybe comics will be the art that will make us all share the qualities of that surprising "third ear" Nietzsche said he possessed in *Beyond Good and Evil.*

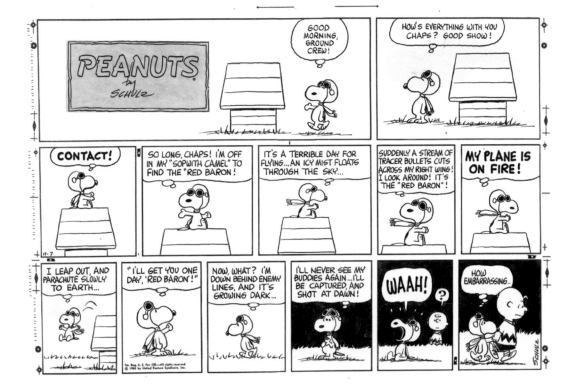

AN EARLY SKIRMISH BETWEEN SNOOPY AND THE RED BARON

Charles Monroe Schulz
1917–2005
Peanuts
(Sunday page)
July 11, 1965

Umberto Eco wrote this beautiful portrait of the father of Snoopy: "He doesn't drink, he doesn't smoke, he doesn't swear. He was born in Minnesota in 1922. He's married and has five children, I believe. He works alone, has no neuroses of any kind. This man whose life is so disastrously normal is named Charles M. Schulz. He is a Poet." What could one possibly add to that? Although his creator is gone, Snoopy lives on, in the legendary Mount Parnassus surrounded by the nine muses.

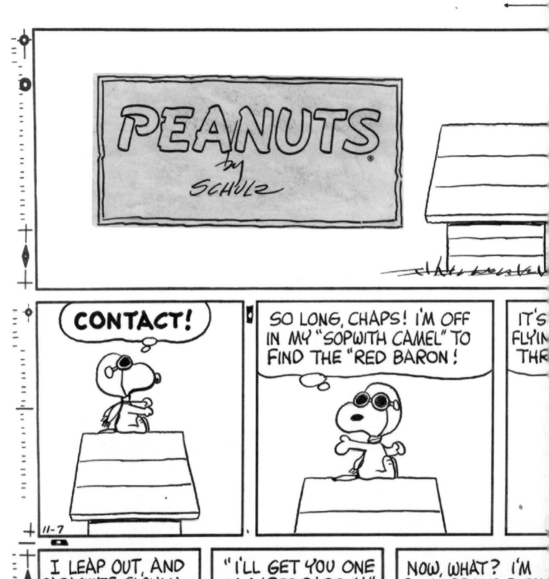

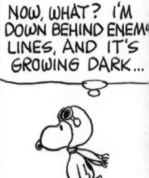

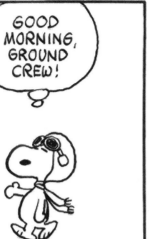

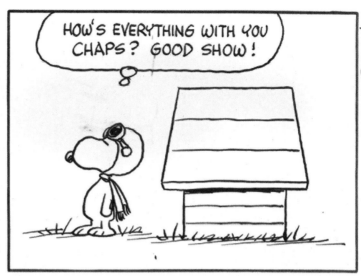

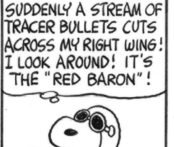

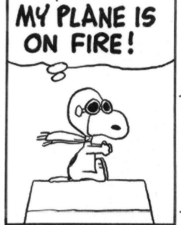

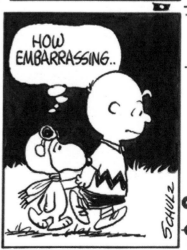

"I GOT MY FIRST PAYING JOB AS A CARTOONIST FOR COMIC BOOKS WHEN I WAS ELEVEN-AND-A-HALF"

Joe Kubert
1926–2012
Enemy Ace
Issue #138 *The Slayers and the Slain!* (cover)
1968

Saying Joe Kubert was precocious is an understatement. Creator of the Joe Kubert School of Cartoon and Graphic Art, first man to ever publish 3-D comics, he was a creator of war stories and essential player during the silver age of the comics industry. *Enemy Ace* stands out in his patriotic productions, as, strangely enough, he modeled his hero on the German Red Baron, Manfred von Richthofen. This anti-hero flying ace is drawn here with great cleverness, the image bringing together the psychology of a close-up and the battle seen from afar, slashing through the hero's face.

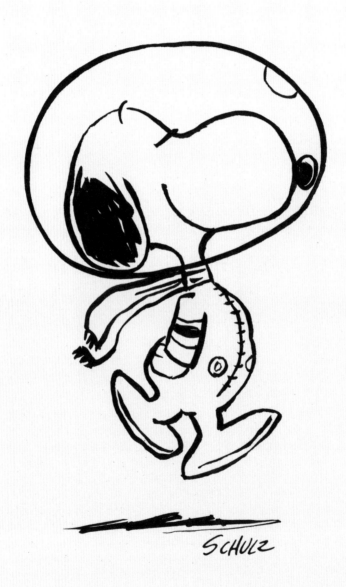

NASA AND THE BEAGLE

Charles Monroe Schulz
1917–2005
Apollo Project
(illustration)
1968

NASA's website explains this historic drawing: "NASA has
shared a proud association with Charles M. Schulz and his
American icon Snoopy since Apollo missions began in the
1960s. Schulz created comic strips depicting Snoopy on
the Moon, capturing public excitement about America's
achievements in space. In May 1969, Apollo 10 astronauts
traveled to the Moon for a final checkout before lunar
landings on later missions. Because the mission required
the lunar module to skim the Moon's surface to within
50,000 feet and 'snoop around' scouting the Apollo 11
landing site, the crew named the lunar module Snoopy."

BELGIAN JOURNALIST FIRST MAN TO WALK ON THE MOON

Hergé, born George Rémi
1907–1983
Tintin
Volume 17, *Explorers on the Moon*
1954

Tintin had already conquered the world when Hergé
decided his reporter should explore space. To understand
this new territory Hergé consulted his eccentric friend
Bernard Heuvelmans, a founder of cryptozoology—basically
a Bigfoot hunter—who had recently written *Man Among
the Stars*. Heuvelmans became part of the team that helped
Hergé to make the story as realistic as possible. But realism
did not eclipse poetry, and the resulting book played a
major part in the success of the series, which has been
translated into seventy languages and sold
more than two hundred million copies.

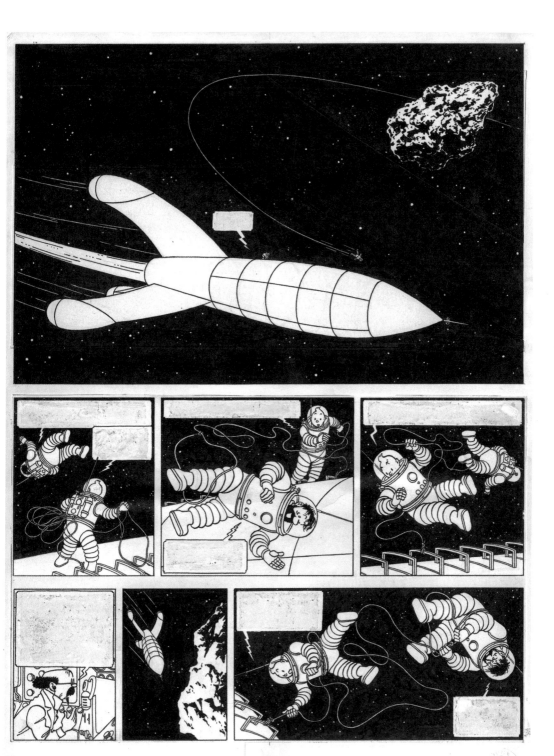

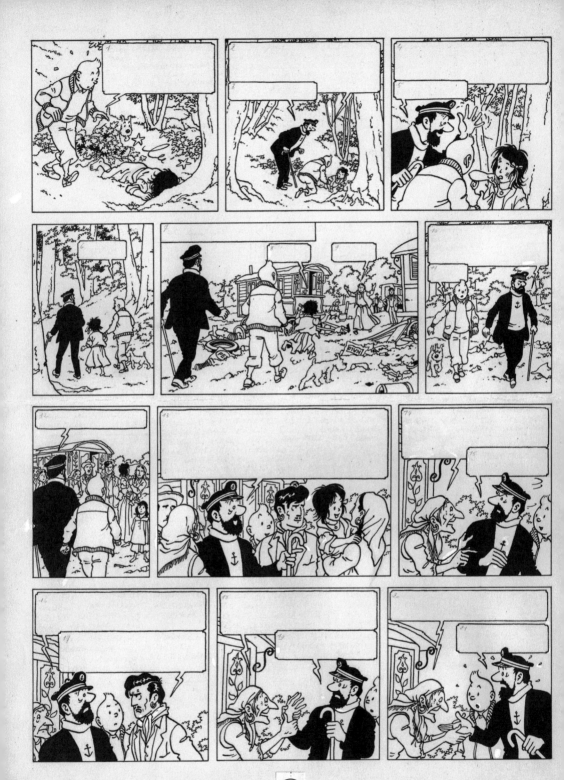

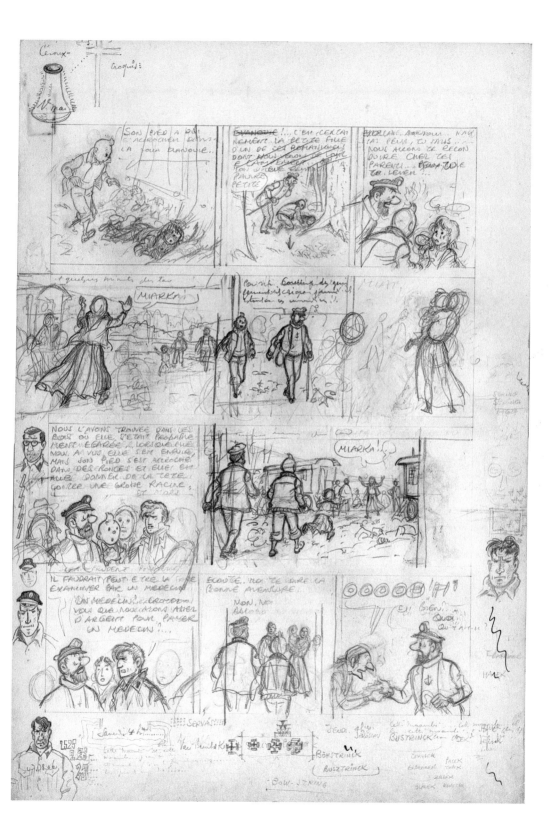

<　**PEN-AND-PAPER OPERA**

Hergé, born George Rémi
1907–1983
Tintin
Volume 21, *The Castafiore Emerald*
1963

Like certain saxifrages that flower after seventy years of
waiting, in the last of his works, Hergé's art reached its
apogee. He had evolved from his first colonialist ideas
toward a socially aware and egalitarian worldview. His
dialogue with the philosopher Michel Serres added
fabulous layers to his vision of communication and music.
His drawing became crystal clear, his sense of adventure
so acute it applied to everyday life and the inner world of
his characters. This emerald, a stone greatly admired by
alchemists, is a masterpiece of penciling, of inking,
of storyboarding, and of writing.

"THE MAGAZINE > FOR THE YOUTH FROM 7 TO 77"

Hergé, born George Rémi
1907–1983
Tintin magazine
Issue #649 (cover)
March 1961

A GROOM, A REPORTER, AND OTHER ANIMALS

André Franquin
1924–1997
Spirou et Fantasio
Volume 19, *Panade à Champignac* (cover)
1967

The celebrated adventures of *Spirou et Fantasio* have been
drawn by multiple authors since they began in 1938, but
by far the most powerful influence on the ongoing series
was the work of André Franquin. This technical genius,
inexhaustible inventor, and great humorist was sadly
plagued by depression, which he refers to on several
occasions in this iconic album. The character Fantasio
even guzzles the antidepressants left behind by the author.
Luckily his sense of humor prevailed
and has delighted generations of readers.

PAR Franquin

ET

LES

Mes perspectives sont fuyantes !

A REBEL WITH A CAUSE
AND A CUTE PUPPY

José Cabrero Arnal
1909–1982
Pif le Chien
(daily strip)

José Cabrero Arnal is an essential Spanish comic-book
author. He had first imagined a dog named Top el Perro,
in the Spanish magazine *TBO* in 1935, but he is famous for
creating another dog, Pif le Chien, in 1948, for the daily
French newspaper *L'Humanité*. What happened in the
meantime? He had fought Fascists in the Spanish Civil
War, been incarcerated in the infamous detention centers
of the south of France, and then deported to Mauthausen
concentration camp. He barely survived. Nonetheless his
creations remained funny, cheerful, and popular,
while deeply committed to denouncing injustice.

ISAAC NEWTON BECOMES A RUNNING GAG

Gotlib, born Marcel Gottlieb
1934–2016
Jean-Claude Mézières
1938–2022
Pilote
Issue #493 (cover)
1969

The prince of French funnies, Gotlib had a very hard
childhood. After his parents were deported from France, he
grew up hiding from the Nazis, living in a barn with a goat
and a few pencils. He became one of the funniest comic-
book authors in history. One of his running gags concerned
Sir Isaac Newton getting hit on the head by an apple.
He was also very fond of his alter-ego ladybug, and an
endearing goat—whose presence he never explained
until after retiring from drawing. His powerful
resilience brought fits of laughter to millions.

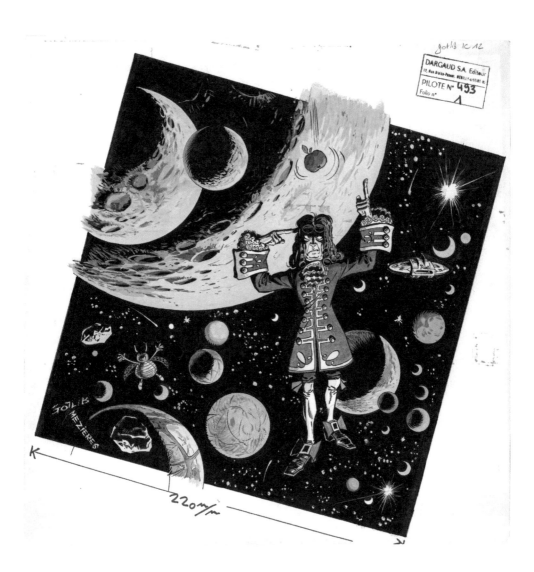

DARGAUD S.A. Éditeur
12, Rue Biaise-Pascal. NEUILLY-s-SEINE H.
PILOTE Nº 493
Folio nº 1

gotlib K 12

220 m/m

GOTLIB
MÉZIÈRES

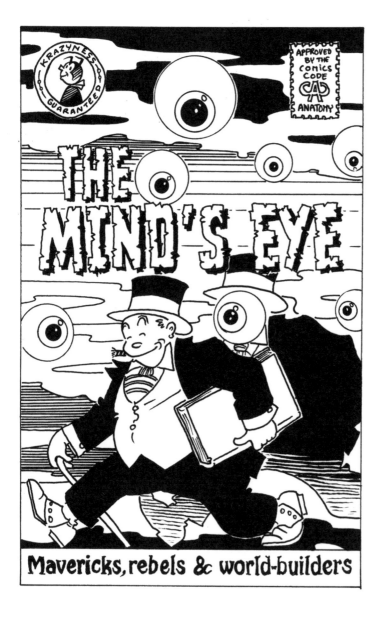

- III -
THE MIND'S EYE
Mavericks, rebels, and world-builders

In comics the reader is in complete control of the experience. They can read it at their own pace, and if there's a piece of dialogue that seems to echo something a few pages back, they can flip back and check it out, whereas the audience for a film is being dragged through the experience at the speed of twenty-four frames per second.

Alan Moore

While comics can create wonders—the third ear brought about by the mixing of tongues being just one—there are also negative aspects of the art, which can cloud the mind's eye.

Let's start by questioning the medium's massive commercial success. Superhero movies have become one of the most popular and profitable genres worldwide and are now firmly positioned among the highest-grossing film franchises. It is beyond sociological doubt that they are now a main part of the contemporary mindset. According to CNBC, "Disney bought Marvel for $4 billion in 2009; a decade later it's made more than $18 billion at the global box office." A closer examination shows that in 1995 superhero movies represented a marginal 3.48 percent of the market share, shooting up to 31.31 percent in 2021. The tenfold leap of this jack-in-the-box-office has massive economical and political consequences.

No genre can occupy a third of worldwide entertainment without having societal aftereffects. Alan Moore was one of the first comic-book authors to remind us to be wary of superheroes. He had already explored their violent and fascist tendencies in his stunning, classic 1987 graphic novel, *Watchmen.* This iconic deconstruction of the American psyche brought to light something disturbing: Superman and Nietzsche's Übermensch are exceedingly similar.

THE MIND'S ARCHITECTURE

François Schuiten (art)
b. 1956
Benoît Peeters (text)
b. 1956
Les Cités Obscures: La Mémoire de Piranèse
(illustration)
1999

The fascinating creations born of the collaboration
between François Schuiten and Benoît Peeters are like
cathedrals holding their own secret symbolism. They offer
the reader a political and moral vision of architecture,
which is influenced by both Roland Barthes' semiology
and Foucault's philosophy of urban space. In addition
to comics, they designed a Parisian metro station and
worked in the French army's Red Team. This homage to
the Italian engraver Piranesi is a perfect illustration of the
combination of their passion for architecture,
history, and comic-book storytelling.

La mémoire de Piranèse — atelier par le musée de Villeneuve sur Lot — 1997

Nietzsche hated antisemitism and fought valiantly against the early shoots of national socialism that appeared in his day. But, after his death, his sister and a group of rabid Wagnerites chopped up his texts, and only kept the parts that satisfied the growing Third Reich. Thus, totally against his original intention—and which no doubt would have had him spinning in his grave—Nietzsche's philosophy was adopted by many Nazis, with the Übermensch becoming its own enemy. Regarding the birth of Superman, it has often been said that Joe Shuster and Jerry Siegel found through this "immigrant" from Krypton a fictional, kid-friendly way of speaking about their Jewish and working-class origins. Superheroes were among the first to enroll against the Reich.

Gradually, like the Übermensch, the superhero became a trope for those who believe that problems should be fixed with your fists, imperialism isn't much of a problem if it lets you choose your brand of consumerism, and vendetta is the only path to justice. As the comics industry commodified the original dissent of the artists, popular rebellion evolved into populist *doxa*. There is a serious glitch in the kryptonite. Forty years after his deconstruction of the superhero, Alan Moore has not surrendered, reminding us that the incredible growth of superhero films has parallels with the worldwide surge in populism. It is undeniable that populism shares with superheroes a passion for personal and vengeful justice, along with the naïve belief that providential personas can untangle social crises through the sheer aura of their power. Alan Moore explains:

> Most people equate comics with superhero
> movies now. That adds another layer of difficulty
> for me. ... They have blighted cinema, and also
> blighted culture to a degree. Several years ago
> I said I thought it was a really worrying sign

that hundreds of thousands of adults were queuing up to see characters that were created fifty years ago to entertain twelve-year-old boys. That seemed to speak to some kind of longing to escape from the complexities of the modern world, and go back to a nostalgic, remembered childhood. That seemed dangerous, it was infantilizing the population.

Once Moore's analysis is seen in parallel with the murky political ideas that Disney was displaying in the 1930s, the Marvel-Disney monopoly raises concerns. For example, the 1933 Disney animation *Three Little Pigs* depicts the Big Bad Wolf disguised as a Jewish peddler speaking with a Yiddish accent. And on December 8, 1938, Walt Disney held a reception for a distinguished guest: Leni Riefenstahl, a dancer and actress mainly known for masterminding Nazi film propaganda. All major Hollywood players boycotted Riefenstahl's visit to Hollywood, but Walt Disney generously gave her a tour of the studio and showed her the prancing unicorns in the storyboard to *Fantasia*. At the time he was fiercely opposed to the United States entering the war, and cared a lot about his German market. It is said Hitler loved Disney's *Snow White*, a profoundly disturbing fact. Alan Moore continues:

> This may be entirely coincidence but in 2016 when the American people elected a National Socialist satsuma [as Moore calls Donald Trump] and the UK voted to leave the European Union, six of the top twelve highest-grossing films were superhero movies. Not to say that one causes the other but I think they're both symptoms of the same thing—a denial of reality and an urge for simplistic and sensational solutions.

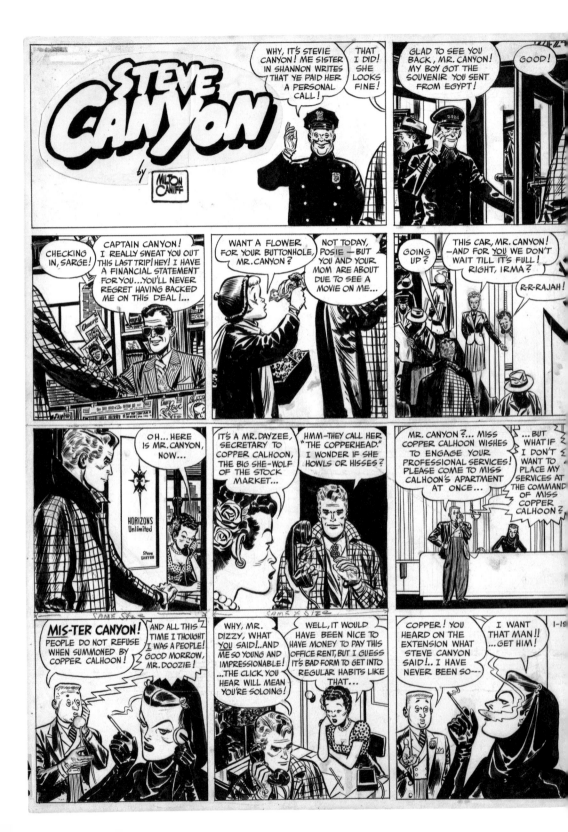

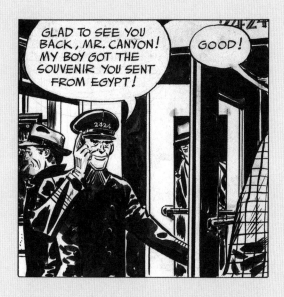

UMBERTO ECO DIGS A CANYON

Milton Caniff, born Milton Arthur Paul Caniff
1907–1988
Steve Canyon
(Sunday page)
January 19, 1947

This strip made history, thanks to Umberto Eco. He did a lot for comics. One of the first to acknowledge the medium as art, Eco applied his interpretative semiotics to this specific strip, making it a historical milestone in the recognition of the art form. Eco did not forgive easily the militaristic, patriotic biases of Caniff's work, but he dove into the technical storytelling that happened from box to box. In doing so, Eco shed light on the new world of narrative possibilities found in comics.

BLOOD
IN THE INKPOT

Chester Gould
1900–1985
Dick Tracy
(Sunday page)
February 20, 1938

Umberto Eco once wrote that Chester Gould had a "sanguinary pencil." Long before his character was played by Warren Beatty, Gould influenced American culture with his peculiar, hard-boiled style. The blood spilled in 1930s Chicago seeped into his comics: Gould drew Al Capone as Big Boy and would go on to add most bigwigs of organized crime to his cast of characters. The move was controversial, causing some of the public to withdraw in horror. But bloodshed had been invited into comic-book storytelling and it was not ready to leave.

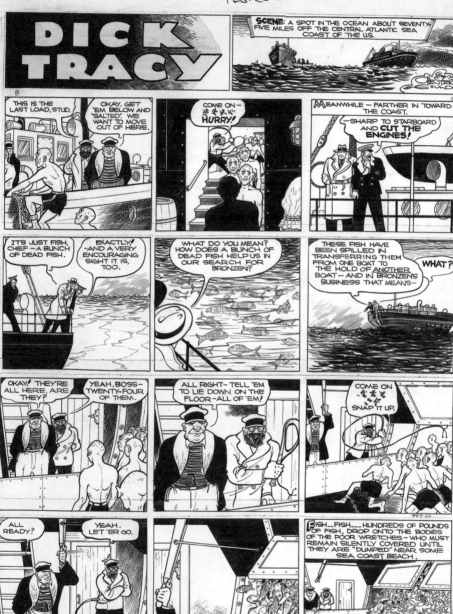

The once marginal world of comics has eaten up the mainstream, and it's not always the best of the art that got on top. Alan Moore looks beyond recent history: "I think a good argument can be made for D.W. Griffith's *Birth of a Nation* as the first American superhero movie." For those who have not seen the 1915 silent epic, *The Birth of a Nation* was originally called *The Clansman*—but might as well have been written with a K. The film's ideology was eloquently summarized by the historian Steven Mintz: "Reconstruction was an unmitigated disaster, blacks could never be integrated into white society as equals, and the violent actions of the Ku Klux Klan were justified to reestablish honest government." Sadly, the parallels Alan Moore draws between Klansmen and our spandex-clad avengers are very well thought through, and prove to be a sound theory.

Despite the beauty comics can create, Umberto Eco is on to something when he writes, "as a rule, authors conform: thus the comic strip, in most cases, reflects the implicit pedagogy of a system and acts as hidden reinforcement of the dominant myths and values." This sounds like a terribly global accusation for a polymorphous art, but Umberto Eco loved comics. He detailed how he came to think of most of the iconic comics: "Dennis the Menace confirms the basically happy and irresponsible image of a good middle-class family that has turned Deweyan naturalism into an educative myth ready to be misunderstood, mass-producing a long line of neurotics." In more than one sense this is the root of our contemporary problematic relationship with nature. As for Little Orphan Annie, Umberto Eco shows how she became "for millions of readers the supporter of a nationalistic McCarthyism, a paleo capitalist classism, a petty bourgeois philistinism ready to celebrate the pomps of the John Birch Society." Each of Umberto Eco's attacks hurt, because they come from someone who has thoroughly read

and considered these comics as real works of art. Even the
great McManus is looked at mercilessly: "*Maggie and Jiggs*
reduce the sociological problem of American matriarchy
to a simple, individual situation." Despite admiring Milton
Caniff enough to make his work the subject of the first
ever semiotic analysis of comics, Eco admits "*Terry and
the Pirates* lent itself faithfully to a nationalist-militarist
education of the young American generations." Even the
gripping violence of Chester Gould's stories found Eco ready
to fight back: "*Dick Tracy* brought the sadism of the action
thriller within everyone's reach not only through its plots
but also through the very sign of an extremely neurotic and
sanguinary pencil (and it is of no matter that it considerably
refreshed the palate of its audience.)" It is tempting to
disagree with the great Italian writer by saying that comic-
book authors do not always conform, by recalling that
social criticism was often found in the early comics, but Eco
retaliates: "Even protest and social criticism, when they did
exist, were politely confined within the system and reduced
to storybook dimensions." These words were published in
Apocalypse Postponed, translated into English in 1994, but the
original was written in 1964, a few years before comic-book
artists ceased conforming, with the rise of the underground.

Does this apply to all the tricksters and shape-shifters
who invented a new way of seeing the world? Even
before the rise of the underground of the 1960s and 70s,
there was a long line of mavericks, rebels, and world-
builders functioning covertly within the ridiculously
heavily corporate world of comics. When asked about the
future of contemporary comics, Alan Moore answers:

> It's too early to make optimistic
> predictions but you might hope that
> the bigger interests will find it more difficult

WHEN SOCIETY IS "NIX"

Rudolph Dirks
1877–1968
The Captain and the Kids
(Sunday page)
August 17, 1902

Rudolph Dirks is significant in the history of comics, and
not only because of his art. After fifteen years of faithful
service drawing his jokes, in 1912 he requested from the
Hearst syndicate a year's leave to tour Europe with his wife.
It did not go down well. After a long historical legal case the
federal courts ruled that the *New York Journal* retained the
rights to the title *The Katzenjammer Kids*. And ever since,
this American exception has prevailed: weirdly,
the publisher is still considered the owner
of the characters invented by artists.

to maneuver in this new landscape, whereas
the smaller independent concerns might
find that they are a bit more adapted.
These times might be an opportunity for
genuinely radical and new voices to come
to the fore in the absence of yesteryear.

This looks likely, and it was made possible by a
long line of less well-known artists, those who
don't always steal the limelight, but who long ago
embarked upon the necessary deconstruction. Take,
for example, the book by Peter Maresca, *Society is Nix*!
Its complete title is self-explanatory—*Society is Nix:
Gleeful Anarchy of the Dawn of the American Comic
Strip, 1895–1915*. In his witty introduction, "Anarchy
Rules!," the editor Peter Maresca explains his aim:

> From the very first color Sunday supplement,
> comics were a driving force in newspaper
> sales, even though their crude and often
> offensive content placed them in a whirl
> of controversy. Sunday comics presented
> a wild parody of the world and the culture
> that surrounded them. Society didn't stand
> a chance. These are the origins of the American
> comic strip, born at a time when there
> were no set styles or formats, when artistic
> anarchy helped spawn a new medium.

As the art shown in his book indicates, what Maresca names
"artistic anarchy" is still active. The century-and-a-half
of comic-book history sometimes gives the impression
that the rules are set, but everything is still to be invented
in the medium, and gleeful anarchy should still stand.
The unconstrained originality shown in
Wee Willie Winkie's topsy-turvy world,

or in the Kin-Der-Kids' lush and versatile fancies,
in Happy Hooligan's hobo rambling, or in the
Explorigator's experimentation, is still the kind
of energy the medium needs in order to avoid the
complacency that comes from succumbing to the
venomous embrace of political correctness.
The fabulous contemporary artist Chris Ware
was particularly moved by the collection of
radical creations featured here, saying:

> The most amazing thing about this book is how
> incredibly experimental and avant garde it is.
> Most of these pages are over one hundred and
> ten years old and there's more interesting visual
> experimentation, narrative experimentation,
> and simple, strange, weird human honesty
> about what was going on in America at that
> time—it's like the top of the American pumpkin
> was cut open and you just plunge your hand in
> and come out with stringy slop and seeds. But
> it's a beautiful example of cartoonists trying
> to find out what this new medium possibly
> could be, and they really have no idea. It's
> a wonderful time in the history of comics
> because every single page is an incredible
> experiment in "How do I tell a story visually?"
> and "What happens when I put one picture
> next to another picture?" and "What happens
> to the overall composition of the page?"

Although Eco is right to say that comic-book authors
often conformed to gain institutional acceptance, and
even if superheroes sadly became expansionist autocrats
as they invaded the mainstream, nonetheless, at the
core of the art, still glowing, is a bubbling lava of social
satire and gleeful anarchy, ready to erupt again.

JUNGLE JIM
By Alex Raymond

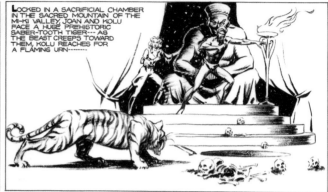

LOCKED IN A SACRIFICIAL CHAMBER IN THE SACRED MOUNTAIN OF THE MI-KI VALLEY, JOAN AND KOLU FACE A HUGE PREHISTORIC SABER-TOOTH TIGER--- AS THE BEAST CREEPS TOWARD THEM, KOLU REACHES FOR A FLAMING URN-------

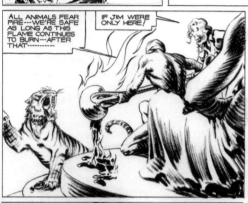

ALL ANIMALS FEAR FIRE---WE'RE SAFE AS LONG AS THIS FLAME CONTINUES TO BURN--AFTER THAT----------

IF JIM WERE ONLY HERE!

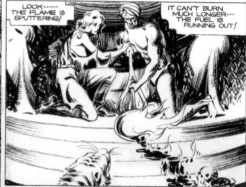

LOOK----- THE FLAME IS SPUTTERING!

IT CAN'T BURN MUCH LONGER---THE FUEL IS RUNNING OUT!

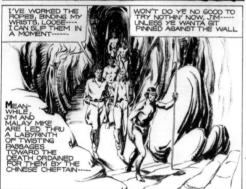

I'VE WORKED THE ROPES BINDING MY WRISTS LOOSE--- I CAN SLIP THEM IN A MOMENT-----

WON'T DO YE NO GOOD TO TRY NOTHIN' NOW, JIM----- UNLESS YE WANTA GIT PINNED AGAINST THE WALL

MEAN- WHILE, JIM AND MALAY MIKE ARE LED THRU A LABYRINTH OF TWISTING PASSAGES TOWARD THE DEATH ORDAINED FOR THEM BY THE CHINESE CHIEFTAIN----

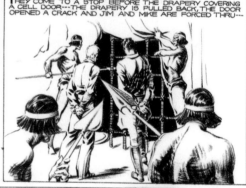

THEY COME TO A STOP BEFORE THE DRAPERY COVERING A CELL DOOR---THE DRAPERY IS PULLED BACK, THE DOOR OPENED A CRACK AND JIM AND MIKE ARE FORCED THRU---

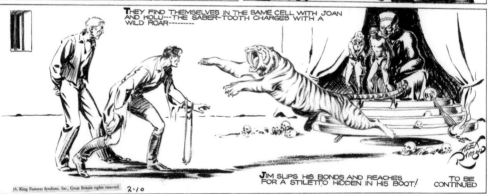

THEY FIND THEMSELVES IN THE SAME CELL WITH JOAN AND KOLU---THE SABER-TOOTH CHARGES WITH A WILD ROAR-------

JIM SLIPS HIS BONDS AND REACHES FOR A STILETTO HIDDEN IN HIS BOOT!

TO BE CONTINUED

2-10

A SABRE-TOOTH TIGER IN THE SACRIFICIAL CHAMBER

Alex Raymond,
born Alexander Gillespie Raymond, Jr. (art)
1909–1956
Don Moore (text)
1904–1986
Jungle Jim
(Sunday page)
October 2, 1935

Whip and pistol in hand, real-life circus mogul Clyde Beatty became famous for jumping into cages with wild animals. American hunter Frank Buck became a star animal-collector with his international safaris. Sitting in his King Features Syndicate chair, the brilliant craftsman Alex Raymond mixed these two characters into one, creating the fictional Jim Bradley. He surrounded his Jungle Jim with desirable John LaGatta-inspired vixens, and sent him out to fight slave traders. The result is a treasure of comic-book history.

FLASH FEARED
BY FASCISTS

Alex Raymond,
born Alexander Gillespie Raymond, Jr. (art)
1909–1956
Don Moore (text)
1904–1986
Flash Gordon
(Sunday page)
May 5, 1935

In 1934, Roosevelt introduced his New Deal, Bonnie and Clyde
were shot dead, and the Space Opera hero Flash Gordon was
born. The drawings were so exquisite, the comic was published
in one hundred and thirty international newspapers. Flash
was the first to make the weird tights-and-cape dress code
fashionable. War-torn Spain, Fascist Italy, and Nazi Germany
all tried to get rid of the interstellar hero, much to the dismay
of his millions of readers. The authorities had to call in cold-
blooded artists like Guido Fantoni in Italy and Edgar P. Jacobs
in Belgium to redraw the sequels to their liking. Although Flash
was around until the early twenty-first century, the original
version was unparalleled. Critic Tom De Haven once said,
"Comparing a *Flash Gordon* Sunday page to anything
that's been around for the past several decades
is like comparing the Andes to a speed bump."

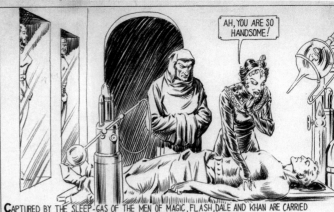

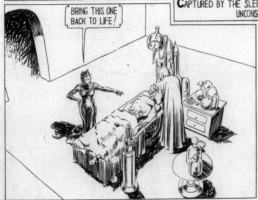

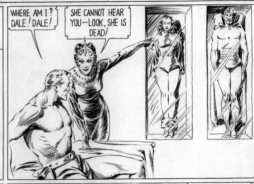

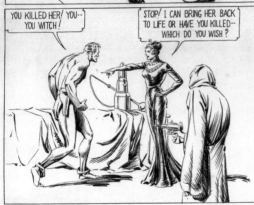

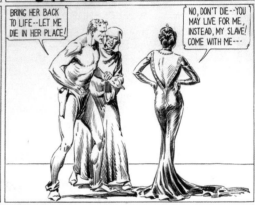

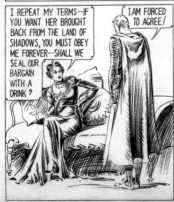

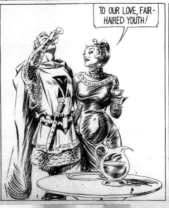

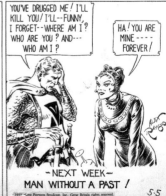

5-5

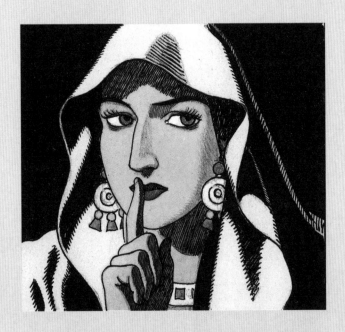

WHEN NORLANDIA AND AUSTRADIA FOUGHT OVER URADIUM

Edgar P. Jacobs, born Edgard Félix Pierre Jacobs
1904–1987
The U Ray
1943

Edgar P. Jacobs is a household name in comics for having
invented Blake and Mortimer. But before he went on to
create the famous characters, under Nazi occupation
he agreed to redraw a sequel to *Flash Gordon* that would
appeal to the authoritarian ideas of the time.
He was so successful at drawing science fiction
in Alex Raymond's footsteps he was commissioned to create
this incredible work, *The U Ray*. "By Jove!" as his heroes
liked to say—a star was born.

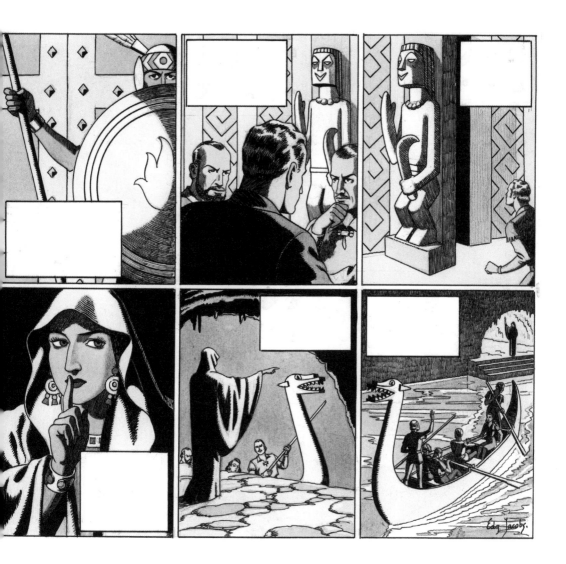

THE HIP HYPNOTIST
OF XANADU

Phil Davis, born Philip Davis (art)
1906–1964
Lee Falk (text)
1911–1999
Mandrake the Magician
(Sunday page)
September 13, 1936

In this story we discover how telepathy and telekinesis help Mandrake travel to the "X" dimension with his faithful Lothar, far away from Xanadu—his high-tech headquarters in New York State—to help Professor Theobold's daughter escape. (Nowadays, when we hear the name Xanadu, we think of the attraction park/prison Citizen Kane built for his beloved in Orson Welles' film.) This comic brought together many of the elements of the superhero story and established a trope of ethnocentric visions of wilderness.

MANDRAKE
THE
MAGICIAN
BY LEE FALK & PHIL DAVIS

Registered U. S. Patent Office.

MANDRAKE AND LOTHAR MEET A PROFESSOR THEOBOLD, WHO TELLS THEM OF HIS DISCOVERY OF A NEW WORLD— THE "X" DIMENSION!

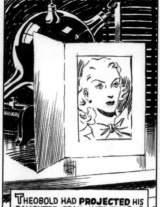

THEOBOLD HAD **PROJECTED** HIS DAUGHTER, FRAN, INTO THE "X" DIMENSION. SINCE HE CANNOT **BRING** HER **BACK**, HE THINKS SHE'S HELD THERE BY AN UNKNOWN, HOSTILE FORCE!

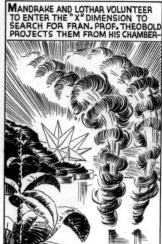

MANDRAKE AND LOTHAR VOLUNTEER TO ENTER THE "X" DIMENSION TO SEARCH FOR FRAN. PROF. THEOBOLD PROJECTS THEM FROM HIS CHAMBER—

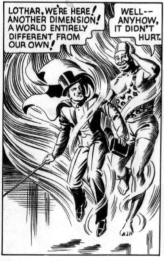

LOTHAR, WE'RE HERE! ANOTHER DIMENSION! A WORLD ENTIRELY DIFFERENT FROM OUR OWN!

WELL-- ANYHOW, IT DIDN'T HURT.

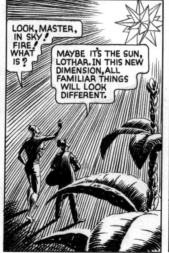

LOOK, MASTER, IN SKY! FIRE! WHAT IS?

MAYBE IT'S THE SUN, LOTHAR. IN THIS NEW DIMENSION, ALL FAMILIAR THINGS WILL LOOK DIFFERENT.

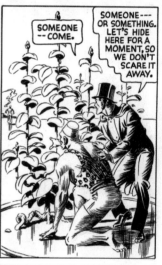

SOMEONE --COME.

SOMEONE--- OR SOMETHING. LET'S HIDE HERE FOR A MOMENT, SO WE DON'T SCARE IT AWAY.

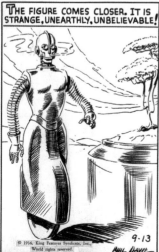

THE FIGURE COMES CLOSER. IT IS STRANGE, UNEARTHLY, UNBELIEVABLE!

9-13

PHIL DAVIS

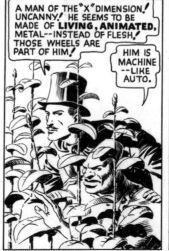

A MAN OF THE "X" DIMENSION! UNCANNY! HE SEEMS TO BE MADE OF **LIVING, ANIMATED,** METAL--INSTEAD OF FLESH! THOSE WHEELS ARE PART OF HIM!

HIM IS MACHINE --LIKE AUTO.

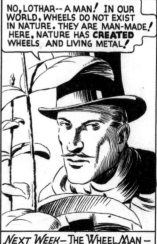

NO, LOTHAR-- A MAN! IN OUR WORLD, WHEELS DO NOT EXIST IN NATURE. THEY ARE MAN-MADE! HERE, NATURE HAS **CREATED** WHEELS AND LIVING METAL!

NEXT WEEK-- THE WHEEL MAN --

El Capitán Trueno

¡La SELVA de los KAMBILI!

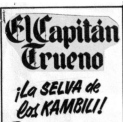

EL CAPITÁN TRUENO, CRISPÍN Y GOLIATH, SE AGARRARON AL GLOBO QUE FUÉ ARRANCADO DEL "THORWALD" (EL CUAL CONTINUÓ MÁS TARDE SU CAMINO). POR LA TORMENTA. ÉSTA LES ARRASTRÓ HASTA MUY LEJOS Y, DURANTE DÍAS Y DÍAS, NUESTROS AMIGOS SUFRIERON EL TORMENTO DE LA SED Y DEL HAMBRE... POR FIN, FUERON A PARAR A UN LEJANO RIBAZO Y, CUANDO IBAN A SER PASTO DE LOS LEONES, INTERVINIERON UN MUCHACHO LLAMADO DIEGO Y UN ANCIANO, EL PADRE FLORIÁN, QUIENES LES SALVARON LA VIDA. NUESTROS AMIGOS LES SIGUIERON AL INTERIOR DE LA SELVA, CUANDO UNA PARTIDA DE ÁRABES LES ATACÓ. EL PADRE Y DIEGO ESCAPARON EN UN CARRO, EN EL QUE IBA OCULTO ALGO QUE PARECÍAN VALORAR MUCHO, Y EL CAPITÁN Y SUS AMIGOS SE ENFRENTARON CON LOS CRUELES PERSEGUIDORES...

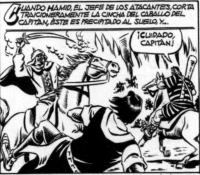

CUANDO HAMID, EL JEFE DE LOS ATACANTES, CORTA TRAICIONERAMENTE LA CINCHA DEL CABALLO DEL CAPITÁN, ÉSTE ES PRECIPITADO AL SUELO, Y...

—¡CUIDADO, CAPITÁN!

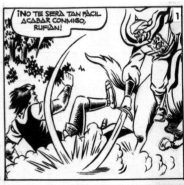

1

—¡NO TE SERÁ TAN FÁCIL ACABAR CONMIGO, RUFIÁN!

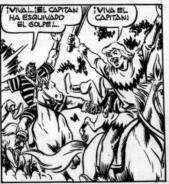

—¡VIVA!...¡EL CAPITÁN HA ESQUIVADO EL GOLPE!...

—¡VIVA EL CAPITÁN!...

TRUENO HACE ALGO MÁS...

—¡NO CORRAS TANTO!...

—...¡QUE QUIERO HABLAR CONTIGO!

—¿TE GUSTA ESTE TIPO DE CONVERSACIÓN?

—¡CUIDADO, CAPITÁN!...¡EL FUEGO QUE ENCENDISTEIS PARA DETENER A LOS ÁRABES, AMENAZA CON CERCAROS A TODOS!

—¡NO PODRÉIS VENCERNOS, ESBIRROS!...¡NADIE PUEDE CONTRA NOSOTROS!...¡SOY EL "CASCANUECES"!...¡HOLA!...

2

—...¡SON COCOS!...

—¡CON LO QUE A MÍ ME GUSTAN!...

—¡YA MÍ!...¡VEN AQUÍ!...TÚ...

—...¡SERVIRÁS DE ABRE-COCOS!...¡JO, JO!...¡AHORA SÍ QUE SOY EL "CASCANUECES"!...

THE KNIGHT WHO WAS TOO ERRANT FOR FRANCOISTS

Ambrós, born Miguel Ambrosio Zaragoza
1913–1992
Capitán Trueno
1956

Capitán Trueno, literally Captain Thunder, was a very popular Spanish series published continuously between 1956 and 1968. The work attracted a large audience, so it suffered from censorship during Franco's dictatorship. It seems ironic today, but the censors were concerned that, as a knight-errant, the captain might stray from family values, especially faithfulness to his eternally beloved lady, Sigrid of Thule. The Crusades should wait; Sigrid needed her man.

A WANDERING HAND
WORKING FOR THE
SHADOW SQUAD

Jesús Blasco, born Jesús Monterde Blasco
1919–1995
The Steel Claw
July 1972

Spanish artist Jesús Blasco started off drawing cute animals,
but somewhere along the way he began adding a Caniff
touch to his expressionist realism, such as in *The Steel Claw*,
one of the most popular British comics of the 1960s and
1970s. In the comic, a laboratory assistant gains the capacity
to become invisible, apart from his artificial hand. At first
he becomes a psychotic criminal, before becoming
a crime-fighter for the British secret service
known as the Shadow Squad.

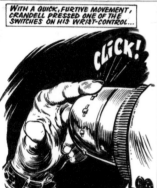

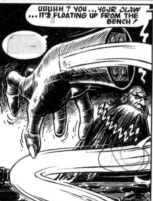

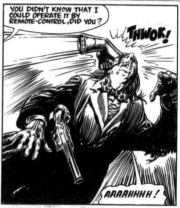

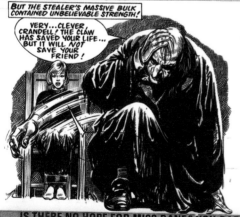

IS THERE NO HOPE FOR MISS DANE? YOU DARE NOT MISS THE NE...

FAIRY TALES,
BEHIND THE SCENES

Pili Blasco
1921-1992
El Príncipe Encantado
Colección Cuadernos Selectos
Editorial Cisne (cover)
1942

Women in comics were excluded from the mainstream until
the twenty-first century. The Spanish artist Pili Blasco is a
good example of this. The Blasco family had four siblings
who worked in comics. Her brother Jesús, the creator
of _The Steel Claw_ seen on the previous page, is the most
famous of the four. Pili was expected to draw for girls
magazines, and fairy tales, and stopped in the 1960s, while
her brothers continued and worked as a team. It is a great
loss to the art of comics that for so long, women were
expected to conform to a retrograde,
domestic vision of storytelling.

THE MARVEL WAY

John Buscema, born Giovanni Natale Buscema
1927–2002
Marvel Heroes
(illustration)
1998

In 1938 Marvel was founded, and in 1998, to celebrate
their first sixty years of existence, John Buscema drew the
whole cast of mythic characters. John Buscema is such an
important actor in the world of comics he could have added
his self-portrait among them. The book he wrote in 1978
with Stan Lee, *How to Draw Comics the Marvel Way*,
is considered a classic, and is still in print.
A close look at the dynamic of his characters
hints at his early training as a boxer.

JOHN BUSCEMA
'98

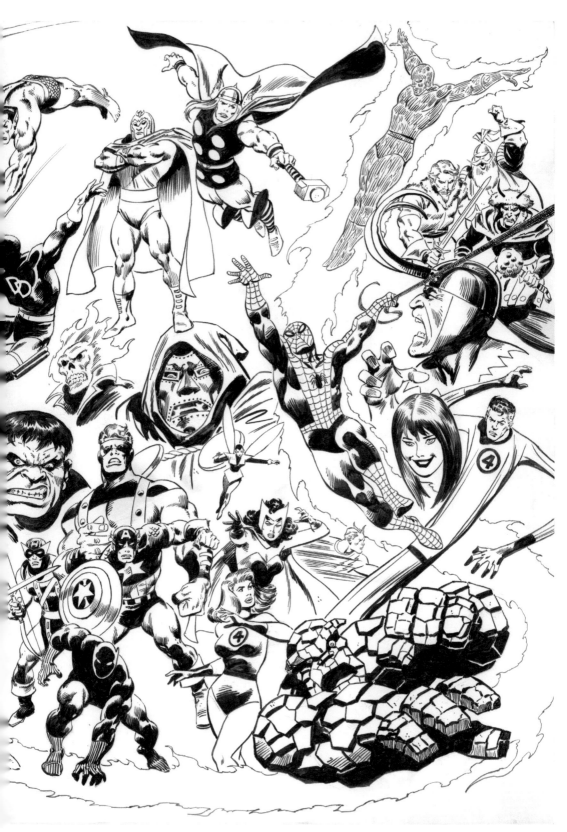

The great thing
about Batman and
Superman, in truth,
is that they are
literally transcendent.
They are better than
most of the stories
they are in.

Neil Gaiman

FEATURING KIRBY'S FIRST KREE

Jack Kirby, born Jacob Kurtzberg
1917–1991
Fantastic Four
Issue #65 (cover)
August 1967

We are in 1967, a former actor enters the White House, and Invisible Girl shouts "I want to be involved with super-markets—instead of super-villains! I'm sick of living in a ridiculous costume!" A pure product of the "Marvel Method" of team creation, this issue of the dysfunctional but endearing team known as the Fantastic Four is the first appearance of the archnemesis that was to become a household name: the Kree empire. At the end of this story, despite their victory, our heroes suspect the Kree might come back. They were correct.

BATS AND
POST-TRAUMATIC SYNDROMES

Neal Adams
b. 1941
Batman
Issue #84 *The Brave and the Bold* (cover)
1969

Batman was created in 1939, the year World War II started.
In an attempt to overcome the trauma of seeing his
parents killed in a Gotham street, Bruce Wayne adopted
the appearance of a bat. Thirty years later, Batman had not
yet been rejuvenated; he would do so a little later, so in this
incarnation he is still the right age to have fought in the
war. Two traumas intertwine in this story as Bruce Wayne is
contacted by the Gotham Museum about a sculpture of the
Archangel Gabriel, supposedly smuggled out of
Nazi-occupied France. It turns out the statue in Gotham
is a fake—the real statue is still in France.

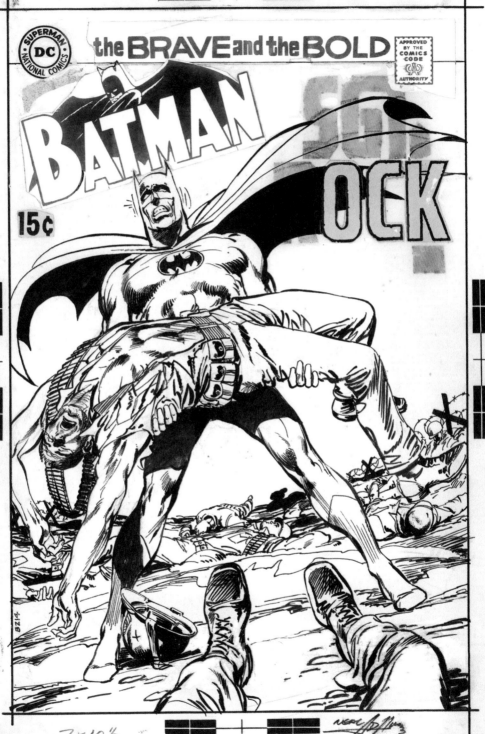

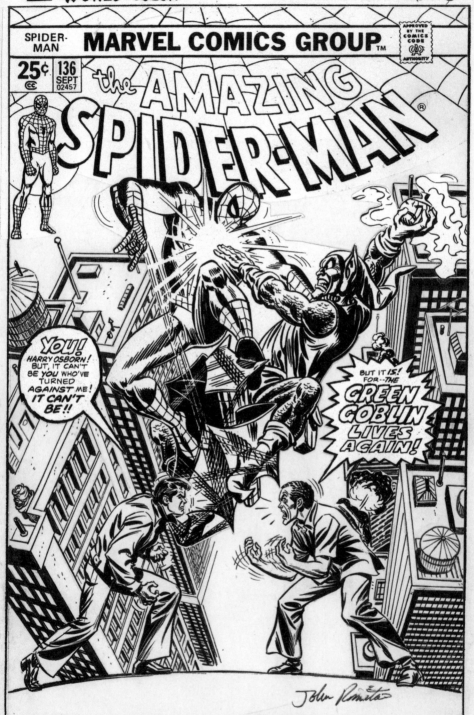

PETER PARKER
QUITS HIS DAY JOB

John Romita
b. 1930
The Amazing Spider-Man
Issue #136 *The Green Goblin Lives Again!* (cover)
September 1974

This cover art with both the Green Goblin and Spider-
Man belongs to what is often considered the most iconic
moment of the Spider-Man narrative. Besides drawing
it, John Romita is said to have contributed to important
narrative elements. During this period the comic began
to include more and more references to contemporary
culture. In this issue, Spider-Man buys the new Ella
Fitzgerald album, *Fine and Mellow*—so it probably
should be read listening to it.

FRENCH DINING HABITS

René Goscinny (text)
1926–1977
Albert Uderzo (art)
1927–2020
Asterix
Volume 4, *Asterix the Gladiator*
1964

In the 1950s, the French artist Albert Uderzo drew a few adventures of Captain Marvel Jr. He later teamed up with René Goscinny, the genius of French humor. Together they created Asterix, a character that was born to be a legend, and who has made generation after generation laugh. Using ancient history as a pretext, the duo created freedom-loving characters who rebelled against the Roman occupation of Gaul. And, as one would expect with French superheroes, all their adventures end with a banquet.

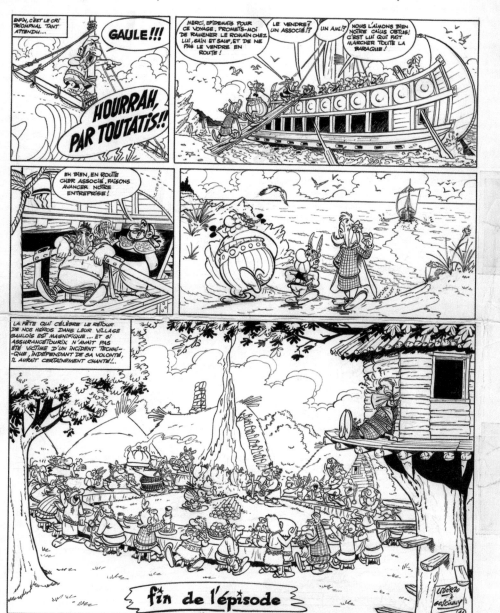

MAGIC POTION
AGAINST IMPERIALISM

Albert Uderzo
1927–2020
Asterix and the Cauldron
Issue #480 *Pilote* magazine (cover)
1969

The struggle between local and global powers has its
forbearers. In one of France's most famous comics, created
by René Goscinny (texts) and Albert Uderzo (art) in 1959,
a typical Gaulish village resists Rome's imperialism with
a mixture of brains, brawn, breeches, and roasted boar.
Their druid Getafix creates a magic potion that helps them
defeat Julius Caesar's legions. This particular vision
of French spirit has been translated into no fewer
than 117 languages—including Latin.

J. GUARNIDO

A HARD-BOILED PUSSYCAT

Juanjo Guarnido (art)
b. 1967

Juan Díaz Canales (text)
b. 1972

Blacksad
Volume 1, *Somewhere Within the Shadows* (cover)
2000

The collaboration between Spanish creators Juan Díaz
Canales (writer) and Juanjo Guarnido (artist) has been
translated into thirty languages thanks to their black cat
protagonist, a private eye in a trench coat with a weasel for
a sidekick. After nearly a decade as lead animator for Walt
Disney Studios in France, Juanjo Guarnido developed his
particular take on anthropomorphic characters
and lavishly watercolored 1950s urban landscapes,
which has become the series' trademark.

LET'S GET CREEPY

Bernie Wrightson
1948–2017
Uncle Creepy
Issue #67 *Creepy*
(page 1)
1974

Stephen King described Bernie Wrightson, this master of horror, best: "I wondered if the source of all that energy might not be more than slightly mad, with bloodshot eyes, a big beer gut, and several coke spoons dangling around his neck. Instead, I was met at the door by a tall, slim, soft-spoken man who was pleasant, obviously intelligent, polite but not in the least shy, and not at all crazy … the craziness all seems to funnel directly into the work. In fact, it makes you a little uneasy to think what might happen if that craziness were escaping in other directions."

WRIGHTSON 74

SPANISH SPAGHETTI WITH PISTOLEROS

Antonio Hernández Palacios
1921–2000
MacCoy
Volume 6
1980

When the Spanish illustrator Antonio Hernández Palacios
started working on *MacCoy*, a classic Western, with the
French author Jean-Pierre Gourmelen, they decided to
feature the French and Spanish that rarely appear in stories
of the Wild West. With its very recognizable passion for
close-ups and cross-hatching, Palacios' work traveled from
the pages of one mythic comics magazine to the next:
Lucky Luke, *Tintin*, *Pilote*, and *Charlie Mensuel*.

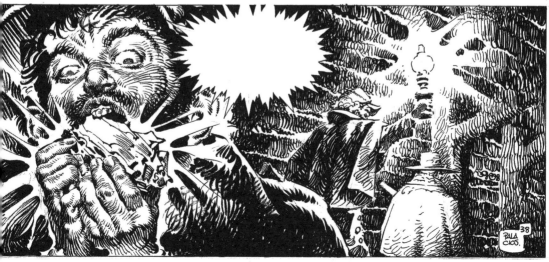

A STREET-SAVVY, HEARTLESS HITMAN

Jordi Bernet
b. 1944
Torpedo
Issue #11 *Año Nuevo Muerta Nueva*
1987

Jordi Bernet started drawing comics at the age of fifteen,
continuing his father's publication following his death.
His international fame and awards came from his work on
Torpedo comic, initially drawn by Alex Toth, and which is an
extremely lurid depiction of organized crime in New York
during the Great Depression. In his realistic work, inspired
by the likes of Caniff and Raymond, Bernet develops
distinctly expressionist compositions
that intensify the violence.

TORPEDO 1936
AÑO NUEVO MUERTE NUEVA

SOPLABAN MALOS VIENTOS A PRINCIPIOS DE LOS 30. TODO DIOS ANDABA DEPRIMIDO. LES HABÍA ENTRADO COMO UNA DEPRESIÓN. A MÍ, EN CAMBIO, ME HABÍA ENTRADO UNA "DE PRISIÓN". LA BOFIA ME HABÍA PILLADO CON UNOS PAVOS MÁS FALSOS QUE EL JUDAS CASCAROTE.

ABULÍ // BERNET

ME LOS HABÍA PASADO EL "ARISTRÓCATA", QUE SE LAS DABA DE CONDE DE "MIENTECRISTO", DE LINAJE MORROCOTUDO, DE TENER SANGRE AZUL CIELO Y UN "MONO-CULO", DE NO VA MÁS, LE RESPALDABA EL ROEDOR, CON SU CARA LLENA DE DIENTES.

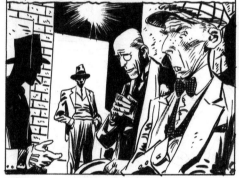

EN CHIRONA LOS DÍAS NO SE ACABAN NUNCA. EMPIEZAN MUY DE MADRUGADA Y TERMINAN MUY ENTRADA LA NOCHE. YO PENSABA A TODAS HORAS EN EL "ARISTRÓCATA"; ME ACORDABA DE SU LINAJE, DE SU FAMILIA, DE SUS "PRONEGITORES", Y DE SU SANGRE AZUL CELESTE...

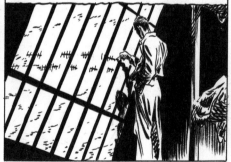

ME SOLTARON EN NAVIDAD. EN EL BRONX HACÍA TANTO FRÍO QUE HASTA LOS MUÑECOS DE NIEVE ESTORNUDABAN. LO PRIMERO QUE HICE FUE IR A CASA A POR "LA TALADRADORA". NADA ABRIGABA TANTO COMO UNA PISTOLA. DONDE HAYA UN ARMA, QUE SE QUITEN LAS BUFANDAS.

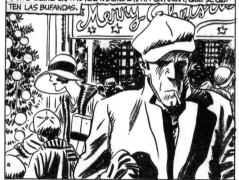

ME MORÍA DE GANAS POR ARREGLAR CUENTAS CON EL "ARISTRÓCATA". PERO AQUEL VIENTO HELADO QUE SOPLABA ME RECORDÓ QUE LA VENGANZA ES CUESTIÓN DE SANGRE FRÍA.

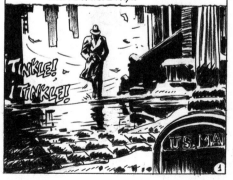

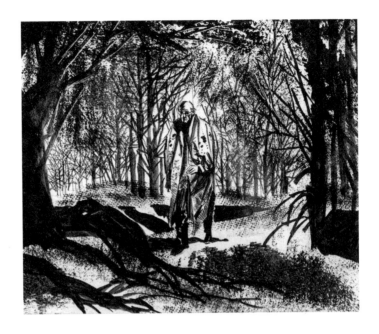

EVADING ARGENTINIAN DICTATORSHIP

Alberto Breccia (art)
1919–1993
HGO, born Héctor Germán Oesterheld (text)
1919–disappeared and presumed dead 1977
Mort Cinder
Volume 1, *Los ojos de plomo*
(page 65)
1962

Argentinian comics spoke against the dictatorship and managed to do so mainly unnoticed. The most famous masterpiece of political subversion was *The Eternaut*, by Héctor Germán Oesterheld, on which Breccia collaborated. Oesterheld and Breccia then penned a biography of Che Guevara, which was quickly censored and led to Oesterheld's execution by the Junta, along with his four daughters. But Breccia and Oesterheld are perhaps best known for their harrowing and expressionist 1962 magnum opus seen here: *Mort Cinder*.

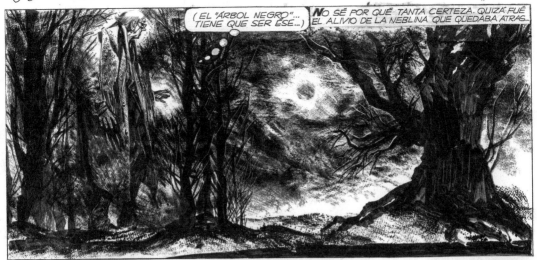

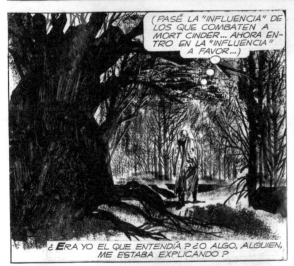

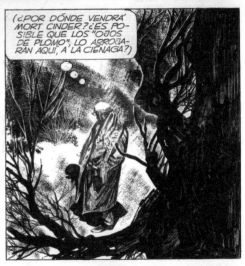

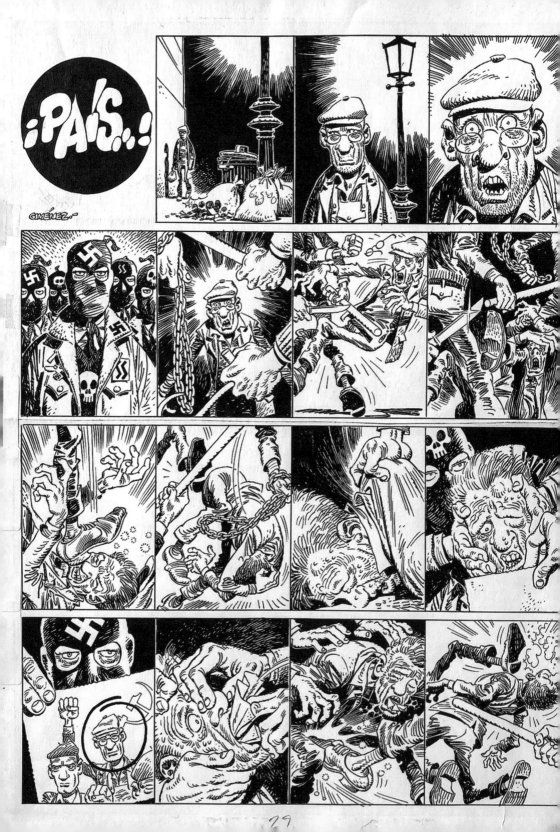

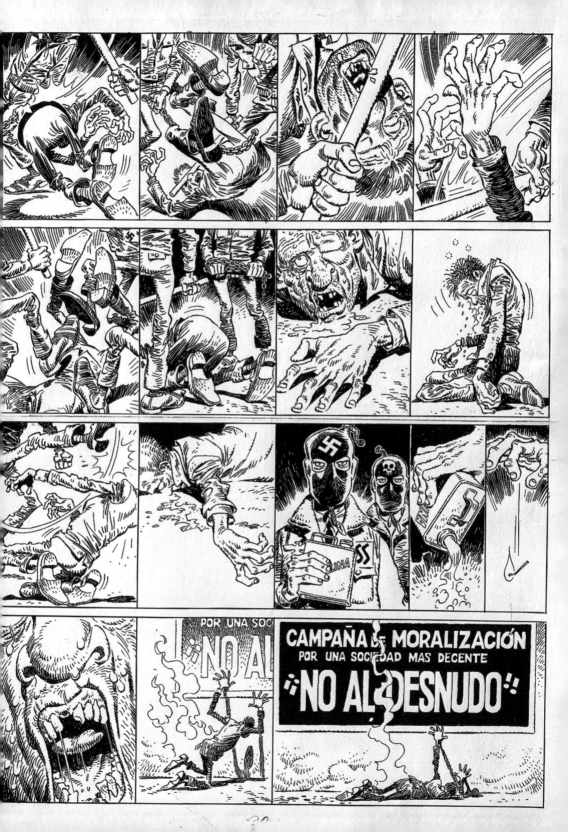

FIGHTING FASCISTS

Carlos Giménez
b. 1941
Álbum España: Una, grande y libre
1976

Mainly known in the world of Spanish comics for his comedy, *Los Profesionales*, or his autobiographical work on growing up in an orphanage, *Paracuellos*, Carlos Giménez also did activist work for the countercultural magazine *El Papus* during the democratic transition in Spain. These two pages are from that period and are in the collection of the Museu del Còmic de Sant Cugat. Its title translates as "One, Great and Free," and is an ironic take on the Francoist motto, for which the author received death threats from right-wing extremists.

FANTASTIC REALISM
TAKES US ON A RIDE

Fred, born Frédéric Othon Théodore Aristidès
1931–2013
Philémon
Volume 9, *L'Âne en Atoll* (cover)
1977

Fred looked like one of his characters. This dark-eyed man with a thick mustache was born into a family of circus performers and drew God as a dog smoking a cigar. He was a portal into another dimension, a poet, a peasant, a dreamer, and a joker. He said most of his ideas came to him in his bathtub, which he believed grew legs, and brought him into an uncanny world, which he then drew for his readers of all ages. He collaborated with Terry Gilliam and French singer Dutronc and created the immortal character Philémon.

couverture
Philemon
L'ÂNE EN ATOLL-

ANE EN ATOLL-Philemon

SILENCE BECOMES
A COMIC-BOOK HERO

Comès, born Dieter Herman Comes
1942–2013
Silence
(page 21)
1979

Born at the confluence of German and French culture, living in the Ardennes forest, Comès created supernatural, black-and-white graphic novels that speak of the scars war makes on our souls, and how witchcraft and mythology continue to imbue our world. His most impressive work is *Silence*, the poignant story of a young mute boy living in the Ardennes after World War II. Capable of mixing incredibly different themes like androgyny, war reporting, poetry, and prehistoric deities, Comès conjured up a unique and totally mesmerizing universe.

...NOTRE PETIT THÉÂTRE AMBULANT ESPÈRE VOUS DISTRAÏRE, ET LE TEMPS D'UNE SOIRÉE, VOUS FAIRE OUBLIER VOS PEINES ET VOS SOUCIS...

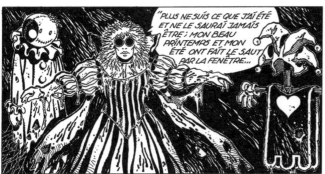

"PLUS NE SUIS CE QUE J'AI ÉTÉ ET NE LE SAURAI JAMAIS ÊTRE; MON BEAU PRINTEMPS ET MON ÉTÉ ONT FAIT LE SAUT PAR LA FENÊTRE..."

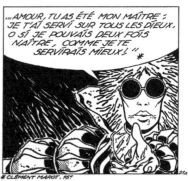

...AMOUR, TU AS ÉTÉ MON MAÎTRE : JE T'AI SERVI SUR TOUS LES DIEUX, Ô SÍ JE POUVAIS DEUX FOIS NAÎTRE, COMME JE TE SERVIRAIS MIEUX ! "*

* CLÉMENT MAROT. 16.°

21A.

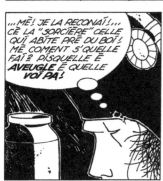

...MÈ! JE LA RECONAÍ!... CÈ LA "SORCIÈRE" CELLE QUI ABITE PRÈ DU BOÍ! MÈ COMENT S'QUELLE FAÍ? PISQUELLE È *AVEUGLE* È QUELLE *VOÍ PA!*

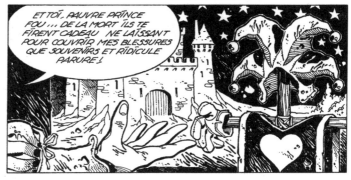

ET TOÍ, PAUVRE PRINCE FOU.... DE LA MORT ÍLS TE FIRENT CADEAU NE LAISSANT POUR COUVRIR MES BLESSURES QUE SOUVENIRS ET RIDICULE PARURE !

...ALORS SATISFAITS... ÍLS PURENT DÍRE, TELS NOIRS CORBEAUX :

* ANONYME.

"SOUVENT JE PENSE A FUNERAÍLLE, A CELA C'EST TOUT MON REMORS. NE ME CHAUT COMMENT ÍL EN AÍLLE DE L'AME, MAIS QUE J'AYE LE CORPS."*

HÍ.HÍ.HÍ,...COME CÈ DRÔLE! CÈ COME LA TEVÉLISION CHÉ LE MAÍTE, JE M'AMUSE BIEN MÈ JE NE CONPREN RIEN A SE QU'ELLE RACONTE!

21B.

THE ANARCHIST'S MUSINGS

Jacques Tardi
b. 1946
À Suivre
Issue #29 (cover)
1980

Adèle Blansec is trapped inside a block of ice, and
Brindavoine—a lost soul from the infantry of World War I—
is entrusted with the mission of awakening her. The French
anarchist Tardi would later work mainly on historical series,
but at this time he was letting his imagination go wild.
This iconic cover of the Franco-Belgian comics magazine
À Suivre was published in June 1980. The magazine, whose
title in English translates as "To be Continued" ran from
February 1978 to December 1997, and represented
a zenith of the freedom of the imagination.

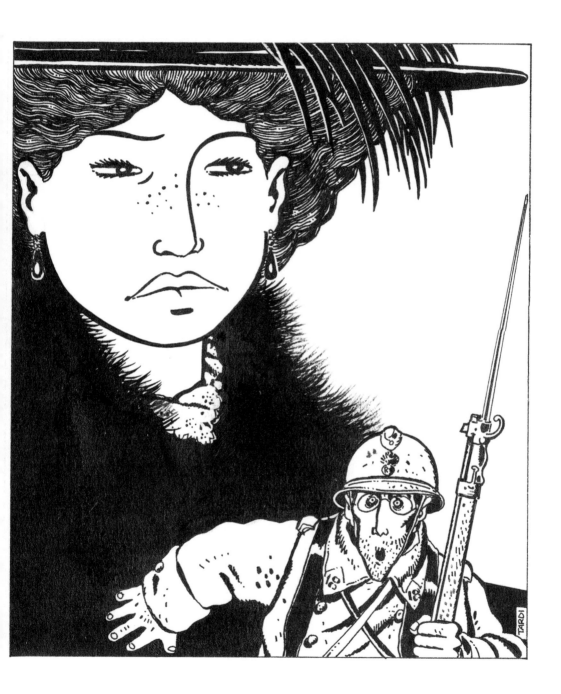

CONCERTO IN O MINOR FOR HARP AND NITROGLYCERIN

Hugo Pratt, born Ugo Eugenio Prat
1927–1995
Corto Maltese
Volume 6, *Celtic Tales* (cover)
1980

The sprite Robin Goodfellow, an arcane Merlin that speaks
like John Dee, a Sinn Féin-enlisted Banshee, and a map
drawn on a missionary's skin; it is difficult to name all
the otherworldly elements inside Pratt's Celtic tales.
Mélodie Gaël plays the harp and all things feel connected,
anthropological, plant, or animal. Hugo Pratt is the great
mastermind, the main esoteric storyteller of comics, and
his stories are both exceedingly accessible adventures
and highly ornate games of hermeneutics.

SIN IS A CITY IN
BLACK AND WHITE

Frank Miller
b. 1957
Sin City
Issue #5 *Big Fat Kill*
1995

With Frank Miller, postmodern unrest breaks into the world
of comics. Harsh angular lines, slabs of darkness splintering
with white gouache—the veneer of society cracks, and vice
and violence splatter out onto the page. At the heart of
this darkness, visibly at ease with the murky feelings of his
protagonists, Frank Miller patiently sculpts fragments of
white, blinding light. In his *Sin City* series, Miller uses the
vertical energy of his layouts to conjure skyscrapers
and the downfall of civilizations.

NAZI OCCULTISTS AND
THE RIGHT HAND OF DOOM

Mike Mignola
b. 1962
Hellboy
Issue #4 *Wake the Devil*
(page 6)
1996

"Don't mess with me, lady. I've been drinking with
skeletons." Thus spoke Hellboy, a wisecracking demon
with a powerful "Right Hand of Doom" who works for the
B.P.R.D.—the Bureau for Paranormal Research and Defense.
Mike Mignola created him as a Molotov-cocktail
of mythology and pulp fictions, set against
a bleak backdrop of broken cemeteries, Nazis occultists,
and creepy baba-yagas. Mignola's blend of heavily inked,
ultra-dynamic drawings and a wry sense of dialogue
made his Paranormal Investigator a major actor
in the international comic-book scene.

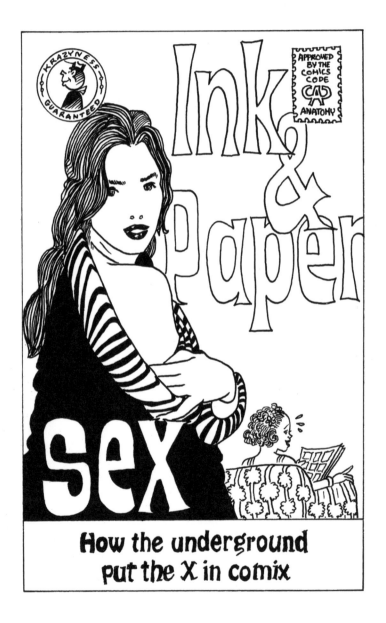

- IV -
INK AND
PAPER SEX
*How the
underground
put the X
in comix*

EXILE AND LACE

Enric Sió, born Enric Sió i Guardiola
1942–1998
Nus y Sorang
1967

In the 1960s the Catalan avant-garde artist Enric Siò produced social satires now considered the first comics to criticize Franco's regime. His erotic drawings drew a lot of inspiration from artists like Guido Crepax, Hugo Pratt, and Dino Battaglia—the masters of the Italian comic-book world. Therefore, when Enric Siò chose self-exile, he went to Italy and then on to France, where he worked with the famous *Charlie Mensuel*. His desire for political and sexual freedom made him a delicate, elegant artist of the Spanish scene.

WHEN THE WEIRDOS WENT TRUCKING

Robert Crumb
b. 1943
Weirdo
Issue #12
1985

The cover of this "special loser" issue of *Weirdo* is drawn
by Robert Crumb and seems to be a sequel to his wordless
1979 piece, *A Short History of America*, in which we see
the American landscape evolving over centuries, from
pastoral calm to an urban jungle of wires and signposts.
In a discussion with Peter Poplaski, Crumb said: "As a kid
growing up in the 1950s I became acutely aware
of the changes taking place in American culture.
I witnessed the debasement of architecture,
and I must say I didn't much like it."

The comics
are where
all the crazy
subconscious stuff
comes out.

Robert Crumb

"There is no great art period without great lovers," wrote the poet Hilda Doolittle, known as H.D. It would therefore be surprising if this exploration of comics avoided the precise parts of anatomy from which love radiates.

In every country in which they flourished, comics featured ostentatious sexuality quite early on. Each tradition has its equivalent of the eye-popping "Tijuana Bibles," pornographic parodies that were sold under the counter from the 1920s, but there are also plenty of examples of more inoffensive takes on sensuality. The medium was considered so vulgar it was open to representations of all sorts of fantasies, from the exquisite to the unpalatable. But if it started as a playground for licentious scribbling, in the 1960s it changed into a mouthpiece for sexual revolution, outspoken feminism, the redefining of gender, and the questioning of taboos. Underground comix, because they were quite often self-published, could embrace the content the Comics Code Authority had cautiously erased from the mainstream allegedly to protect the youth of the day. Thanks to the psychedelic revolution, storytelling was redefined, traditional morality was questioned, and a whole lot of bright colors spilled out onto the page, nicely embodying the spirit of Ian Dury's song that sex, drugs, and rock and roll were, indeed, very good.

BETTY FIRES UP
THE CENSORS

Bud Counihan
1887–1972
Betty Boop
(first and rarest Sunday page)
November 25, 1934

Helen Kane had already sparkled in the musical *Sweetie*,
singing in her squeaky voice "I want to be ba-ba-Bad!"
when Max Fleischer decided to create a new animated-
cartoon character. He added dog ears to Kane's round face,
shortened her dress, revealed her garters, and called her
Betty Boop. This sex-symbol and far-too-liberated woman
soon fell foul of the Hays Code. The censors toned down
as much as they could, but the public wanted more,
and even if the dog ears did not survive, the rest is history.
There are fewer than five Betty Boop Sunday pages
in the world, and this is the first and rarest,
drawn by Bud Counihan, who originated the strip.

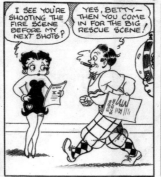

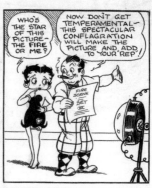

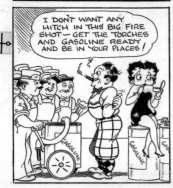

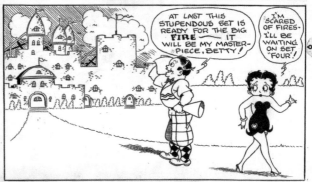

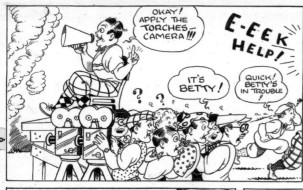

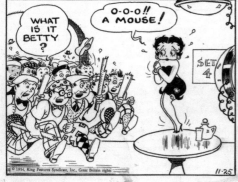

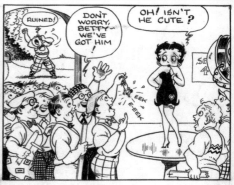

11-25

By the late 1960s a whole scene was bubbling out of San
Francisco's Haight-Ashbury (or Hashbury, to channel
the spirit of Hunter S. Thompson), with rainbow-colored
head-shops, the Blue Unicorn coffee shop, and the Diggers'
anarchist street theater. On the comics front, Jeremy Dauber
summarized the atmosphere just before the Summer of Love:

> Hippies lined up outside the *Barb* publisher's
> home in 1967 to buy wholesale copies, complete
> with underground cartoons, at fifteen cents;
> they resold them downtown for a quarter,
> making enough in a day to support themselves
> for a week. Everyone, including Crumb,
> gawked at the New Age rock posters by future
> partners Rick Griffin and Victor Moscoso,
> visual landmarks clearly reflecting new
> inspiration, cultural and, yes, pharmacological.

Robert Crumb played an essential part in the movement,
but he definitely hated being associated with any crowd
and called Haight-Ashbury "a zoo." His ink is mixed with
so many anxieties and desires that he has puzzled and
mesmerized generations, forcing them to go beyond their
common preconceptions. The work is sometimes so acrid
and startling that the debate continues today: was Crumb
to be identified with the rip-off Zen mysticism of Mister
Natural, or more with the carefree runaway student Fritz
the Cat? With the impish sex fiend Mr Snoid, or the square
stuffed-shirt Flakey Foont? These just led to more questions:
was he being sexist and racist when he depicted Angelfood
McSpade? Crumb himself often said he was challenging
the ideas of his leftwing intellectual readers, mirroring
the stereotypes of 1950s America, and clearly addressing
questions of racism and sexism. He even joked about it
on the cover of his work, writing "For adult intellectuals
only!" He was suspicious of the hippie philosophy from the

start, sporting a tie and tweed jacket, rather than long hair and bare feet, but at the same time he addressed hippies as his readers and considered it understood he was not racist. He never avoided paradox, choosing instead to dive into it head first. It may seem surprising to see how much Crumb has been confused with his characters. Admittedly, he puts a lot of himself into his paper avatars, but so did his predecessors. Identifying the creator with the work is something that became important with the underground, ever since provocative authors became identified as artists and no longer hid behind their superhero creations. It is a treatment that is perhaps unique to comic-book artists, compared to the rest of the art world. In literature, nobody assumes Shakespeare was a raving sociopath because in *Titus Andronicus* his characters live through violence, mutilation, rape, despair, and force each other to eat their own children. On the other hand, just because an author should not be confused with his characters, it does not mean he can't fuel them with his own feelings and questions.

Today's sometimes severe moral judgment of underground comics lacks historical perspective. As psychoanalysis showed, the return of the repressed is the process whereby repressed elements, preserved in the unconscious, reappear in barely recognizable shapes. The underground's paintbrushes were soaked with acid, and what they were painting was the barely recognizable, "Tupperware" conservative, and consumerist America of McCarthyism. It is hard to imagine what it could have meant to grow up in such a prudish society, with preacher Billy Graham claiming rock music was "working in the world for evil," or religious broadcaster Carl Stuart Hamblen hosting a popular radio show called *The Cowboy Church of the Air*. Freud emphasized the "indestructible" nature of unconscious material, and when the indestructible, repressed Captain America—who hallucinated socialist subversion and treason everywhere—

took his first acid trip, it is logical that he would come back in the shape of "barely recognizable" stories spewing an unearthly hodgepodge of primal screams that expressed violence, sexism, racism, injustice, and prejudice. Of course underground comix are disturbing. They were meant to be. Their creators did not believe art was yet another brand of entertainment that should be comforting for the audience. They wanted to trigger public debate by any means.

The scene was not a total tabula rasa, of course. Dauber is right yet again when he says:

> A 1965 psychedelic rock happening in Haight-Ashbury titled 'A Tribute to Dr. Strange' suggested that Ditko's vistas, along with counterculture hero the Silver Surfer and Kirby's cosmic colors, weren't lost on some of the Marvel college fans who'd turned on and dropped out.

If the X in underground comix refers to the subconscious, it was not the genre's first encounter with psychoanalysis—it is no coincidence that comics and psychoanalysis were born at the same time. While Freud's *Traumarbeit*, or dreamwork, became a scientific subject in its own right, it also became the motif of the avant-garde, and that included comics. Freud referred to comics in some of his analyses on pain, collecting Wilhelm Busch's *Max und Moritz*. Even more telling: the sole illustration in *The Interpretation of Dreams* comes from a comic book. Eight years before Freud's book was even available in English, Winsor McCay created his Little Nemo, who became a symbol of dream world. Could there have been a meeting between the artist and the father of psychoanalysis? Didier Pasamonik suggests:

The author very probably met Freud or
Jung—but on this point specialists are
only at conjecture. Winsor tried all he
could to help his psychologically unstable
brother Arthur, confined in a mental
institution until his death in 1948.

Cinema and psychoanalysis were born at the same time and
many studies have been made of the relationship between
the two. We are still waiting for a similar line of enquiry for
comics, which would no doubt be equally revealing. Serge
Tisseron's *Psychoanalysis of Comics* explores this to a degree,
but mainly through questioning the effect of comics on the
reader. The simultaneous creation of a symbolic language,
in comic-book art and in the early days of psychoanalysis,
has yet to be explored. Doing so would help to illustrate how
the language of comics—the language of the subconscious—
crosses borders, creating a new language of the future.
Jacques Lacan said that "the unconscious is structured
like a language." We could go one step further and argue
that the unconscious is structured like a comic strip.

The return of the repressed that happened in the 1960s,
therefore, was not the first meeting point between
subconscious activities and comics. When Ron Mann made
his iconic documentary *Comic Book Confidential* in 1988, the
soundtrack that opens the section devoted to underground
comix is the Electric Prunes song "I had too much to
dream last night"—a brilliant choice. Underground comix
could be defined as a paradoxical dreamwork overload.

It may come as a surprise that in the world of comics,
from one generation to the next, each new movement
acknowledges and respects their predecessors and
successors, much more than in the world of literature

or painting. In 1973 a famous parody of a manifesto
was published in *Short Order Comix #1*. It was called
"The Centerfold Manifesto" and was signed by Bill
Griffith, Art Spiegelman, Joe Schenkman, Robert Crumb,
Justin Green, William Murphy, and Jay Kinney. With
parodic wit, they explained the paradoxical nature
of the X that the underground put in comix :

> It is the artist's responsibility to hate,
> loathe and despise formica ...
> Comics must be personal.
> The artist must strive to create
> quality product ...
> It is our fervent belief that certain
> comics should still be trees!
> It is the reader's responsibility
> to understand the artist ...
> It is also the artist's responsibility
> to understand the artist!
> Swiping is bad, experimentation is good!
> COMICS MUST BE PERSONAL.
> Mental instability is a tool and
> must be kept well sharpened.
> Fantasy must point one back to reality ...
> Of course one man's reality is
> often another man's Fantasy!
> An artist must recognize and polish his craft ...
> Work makes life sweeter.
> Comic Books are their own lesson ...
> We Serve No Master!
> We must study the work of the Masters ...
> Of which we have none!"

TOO HOT FOR
THE TOP BRASS

Milton Caniff, born Milton Arthur Paul Caniff
1907–1988
Male Call
(cover)
1942–46

To contribute to the war effort, Frank Capra and Dr. Seuss
created Private Snafu—"Situation Normal: All Fucked Up."
Milton Caniff opted for a less subtle morale booster, and
invented the voluptuous brunette, Miss Lace, a pin-up with
barracks-room humor who invigorated American G.I.s.
The drawings were offered free of charge to military camp
newspapers. Caniff wanted his *Male Call* to be "spicier"
than his mainstream work, but the military censors' list of
refusals shows the masculinist spirit of the time:
Miss Lace was not allowed to like girls.

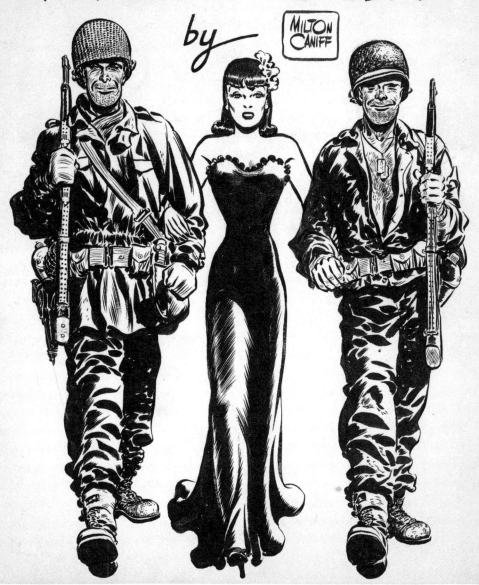

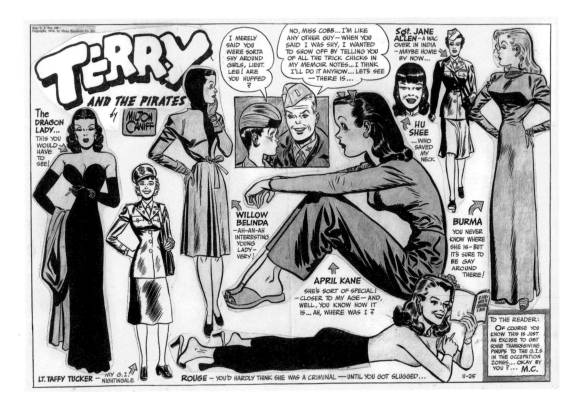

THE DRAGON LADY'S LAIR

Milton Caniff, born Milton Arthur Paul Caniff
1907–1988
Terry and the Pirates
(Sunday page)
November 25, 1945

It is said the owner of the *New York Daily News* handed
Milton Caniff two books: *Wuthering Heights* and a less well-
known title on piracy called *Vampires of the China Coast*.
Out of that discussion and reading appeared the character
that was to make Caniff famous: the Dragon Lady, an exotic
and ambiguous character who evolved beyond good and
evil. Whether it was Hedy Lamar or Joan Crawford who
inspired his drawing, she looks different from the Chinese
lady pirate Lai Choi San who inspired the idea. Either way,
Caniff's femme fatale made his name
more than all his other characters.

SURFING THE GALACTIC MELANCHOLIA

John Buscema, born Giovanni Natale Buscema
1927–2002
Silver Surfer
Issue #3 *The Power and the Prize!*
1968

The Power and the Prize! is an iconic Marvel story written by Stan Lee, penciled by John Buscema, inked by Joe Sinnott, and lettered by Artie Simek. In this tale the melancholic space nomad known as the Silver Surfer first catches the attention of Mephisto. In a parodic reinterpretation of the Temptation of Christ, the ancient devil tries to coax the Silver Surfer with jewels and treasures, which the silvery loner rejects. On realizing he is powerless, Mephisto kidnaps the hero's loved one, Shalla Bal. The old triangular relationship between love, temptation, and demons found a new, successful leitmotiv.

VENUS IN FURS
AND ITALIAN INK

Guido Crepax
1933–2003
Histoire d'O
1974

Guido Crepax was interested not only in Sacher-Masoch
and the Marquis de Sade, but also in reading Marshall
McLuhan, understanding the evolution of design and
storytelling as media evolved. He subsequently created
an idiosyncratic narrative language made of scenes
fragmenting into many panels, with scratchy line work,
hypersolid blacks, and vibrant whites. If he is mainly
remembered for his orgiastic adventures,
this rare splash page from *Histoire d'O*
reminds us he is also an innovative storyteller.

THE GODFATHER
OF FANTASY ART

Frank Frazetta
1928–2010
Women of the Ages
(illustration)
1977

If you are wondering what links Roman Polanski's *Fearless Vampire Killers*, Peter O'Toole in *What's New Pussycat?*, and Meat Loaf's *Bat Out of Hell*, you should stop and consider the prolific and heteroclite career of comic-book artist Frank Frazetta. He helped shape essential characters like Li'l Abner, Buck Rogers, Conan the Barbarian, and Vampirella. This savagely clever craftsman changed the world of fantasy with his battalions of merciless, scimitar-waving oafs, leather-clad vamps, and beefy dragons.

HEROIC FANTASIES

Jeffrey "Catherine" Jones or Jeff Jones,
born Jeffrey Jones Durwood
1944–2011
Idyl
1975

Influenced by artists as radically different as Rembrandt
and Frank Frazetta, Jones played an essential part in the
history of comics. Jeff Jones became Catherine well before
trans rights were discussed openly. It would be intrusive to
mention this transitioning in such a brief presentation if
the questioning of gender was not a cornerstone of Jones's
art. This classic page from *Idyl*, beyond its paintbrush
wizardry, shows all the sensual intelligence
of intertwining yin and yang.

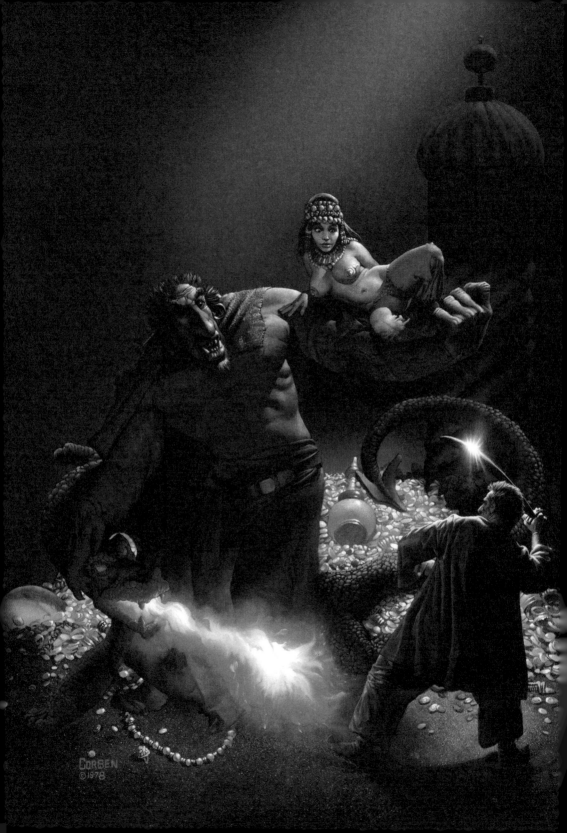

GOBLINS, SEXY VAMPIRES, AND A BODYBUILDING AUTHOR

Richard Corben
1940–2020
New Tales of the Arabian Nights
(cover)
1978

When Mœbius, Dionnet, and Druillet founded *Heavy Metal*, Richard Corben sent them some of his art. It came as a shock and was the beginning of a long collaboration. Mœbius would later say, "Richard Corben stands among us like an extraterrestrial peak. He has sat on his throne for a long time, above the moving and multicolored field of world comics, like an effigy of the leader, a strange monolith, a sublime visitor, a solitary enigma."

TIME-BIRDS
AND WANDERLUST

Régis Loisel (art & text)
b. 1951
Serge Le Tendre (text)
b. 1946
The Quest for the Time-Bird
(series cover)
1998–2020

The six-volume *Quest for the Time-Bird*, written by Serge
Le Tendre and drawn by Régis Loisel, was the first French
heroic fantasy comic. It follows the adventures of a foxy,
redheaded, leather-clad heroine named Pélisse, as she
travels through dangerous territories looking for the titular
bird that can stop time, and thus allow her mother to
perform the ritual to save the world. Readers tore through
the pages, ogling Pélisse, and some of them went on to
become major actors in the heroic fantasy scene.
Since then, *The Quest* has gained iconic status.

OIL PAINTING, FLYING REPTILIANS, AND NUDE AMAZONS

Vicente Segrelles
b. 1940

Rescate Nocturno: The Artwork That Gave Rise To The Comics "The Mercenary"
1979

The work shown here was the origin of Vicente Segrelles' famous character the Mercenary. His particular strand of heroic fantasy fascinated Fellini, was translated into seventeen languages, and was part of the adventure of *Heavy Metal* magazine with which he collaborated. Vicente Segrelles invented a very personal and recognizable approach to creating comics with this series: the whole of his story is made of oil paintings. He is also the nephew of the symbolist illustrator and watercolorist José Segrelles, who had a definite influence on his desire to become an artist.

Comics create a spectral fascination. Their paper characters and forever frozen situations are like motionless puppets with no strings attached. This cannot be transferred to cinema, whose seduction comes from movement, rhythm, and dynamics. It's a radically different style and way of expressing oneself. A different way of communicating, and influencing the gaze.
The world of comics can generously lend cinema its scenarios, characters, stories. But it will not have this ineffable and secret power of suggestion which comes from the transfixed immobility of a pinned butterfly.

Federico Fellini

TWO ITALIAN GENIUSES TRAVEL TO ARGENTINA

Milo Manara, born Maurilio Manara (art)
b. 1945
Hugo Pratt, born Ugo Eugenio Prat (text)
1927–1995
El Gaucho
(cover)
1995

In his mind-blowing autobiography, Hugo Pratt wrote
about how important Argentina was for him. It was there
he was invited to be part of the informal Venice Group, was
highly influenced by Breccia, and wrote his first story as a
complete comic-book author. It is little wonder he decided
to return there with his friend Milo Manara, even if
it meant going all the way back to the nineteenth century.
In *El Gaucho*, we see the conjunction of two Italian
masters of *fumetti*—or "small smoke"—as Italian comics
are called in reference to the appearance of speech bubbles.

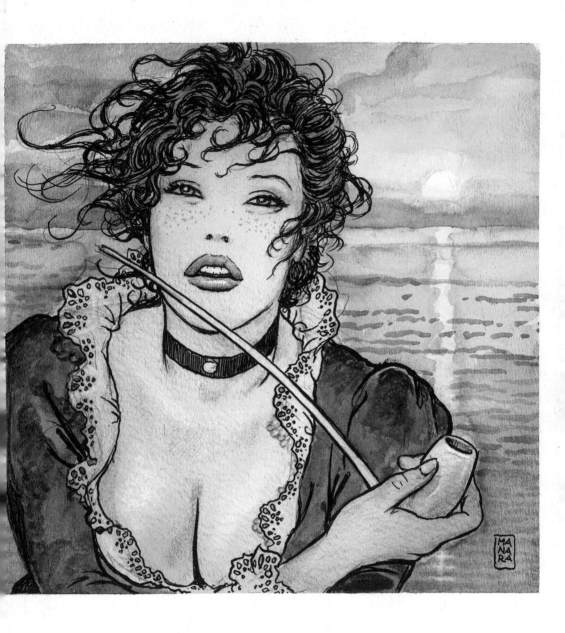

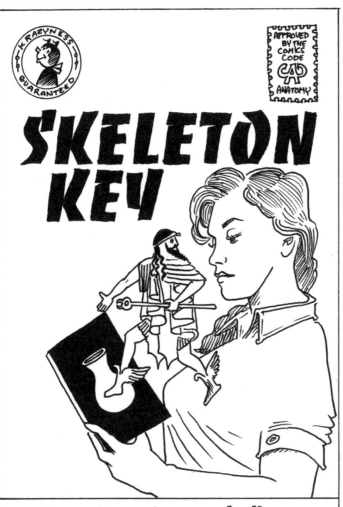

- V -
SKELETON
KEY
Decoding the symbolism of comics

THE INTERPLAY BETWEEN PERCEIVED AND CONCEIVED

Chris Ware
b. 1967
What I May Have Learned Thus Far
2004

Chris Ware began his *Acme Novelty Library* series in 1994, and since then has been producing a sprawling, ornate, and sagacious type of storytelling that continues to push the boundaries of comic-book art. In conversation with Jean Braithwaite, Chris Ware said something essential: "The trick is to not let one mode of thinking or apprehension get the better of one, I guess. It's the interplay between perceived and conceived or the seen and the remembered that makes comics interesting, as well." That definition of the magic at play is as concise and elegant as his drawing.

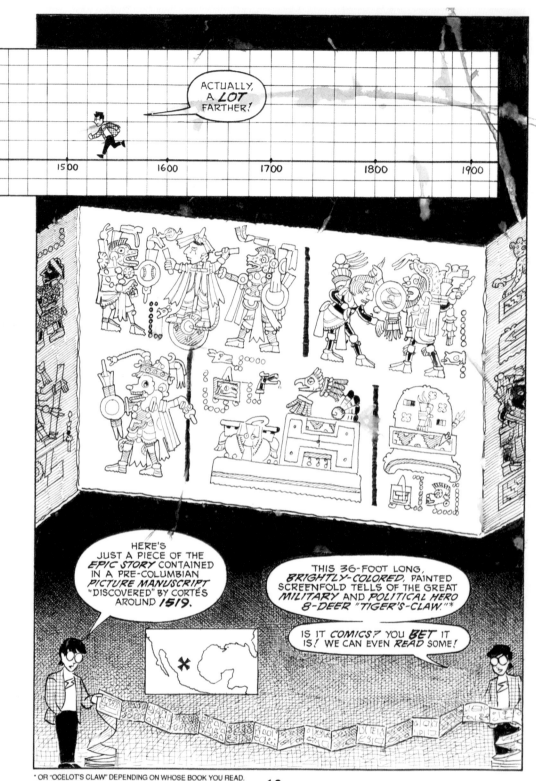

* OR "OCELOT'S CLAW" DEPENDING ON WHOSE BOOK YOU READ.
THIS SEQUENCE IS BASED ON A READING BY MEXICAN HISTORIAN
AND ARCHAEOLOGIST ALFONSO CASO.

A SELF-REFLECTIVE MEDIUM

Scott McCloud
b. 1960
Understanding Comics
1993

"Space does for comics what time does for film!" wrote Scott McCloud in his remarkable book, *Understanding Comics*. For the first time in its history, comics were thought of and analyzed as an art form. Scott McCloud's work is not only groundbreaking, it is also incredibly inspiring for all artists wanting to work in the field. With this iconic page he shows just how complex it is to date the birth of comics.

Scott McCloud has often stated, "I don't think the potential for comics in nonfiction has been exploited nearly as much as it could be." He first started defending this idea in his 1993 book *Understanding Comics.* Since then, a great many nonfiction comics have flourished, including auto-fiction, war reporting, celebrity biographies, ecological manifestos, histories of sexuality, and studies of mathematics, economics, physics, medicine...

McCloud is still right; the potential for comics in nonfiction remains enormous and largely untapped, even though entire shelves of the genre have appeared in bookshops and libraries. This is perhaps due to the fact that a great majority of nonfiction comics are made with a view to the popularization of science rather than artistic potential. Publishers and distributors understand the power of nonfiction comics, but often focus more on the commercial potential, rather than trying to open up a new way of thinking with images. Comics function with a very specific symbolic structure, which could lead to new ways of thinking, not only in art, but also in philosophy and science.

It is tempting to think of this symbolic structure as androgynous. Why? In alchemy, the Magnum Opus, or Great Work, is often represented by an alchemical androgyne. Both active and passive principles of nature

were considered capable of merging into such an entity.
This non-dualist unity of opposites is of the same nature
as the Chinese *Taijitu* symbol (☯) that unites the Yin and
Yang. When opposing principles were harmoniously
conjoined, it was customary to symbolize this equilibrium
by the composite figure of the Hermaphrodite, son of
Hermes and Aphrodite. Put simply, Hermes is a messenger
and Aphrodite represents beauty, and what more could
one hope for a work of art, than to deliver a message with
beauty? As comics bring together visual thought and
language, unconscious mythologies and deliberate artistic
endeavors, popular enthusiasm and individualistic artistic
processes, they bridge more than one paradox. The god of
comics looks very much like an androgynous two-headed
Janus. You can see such a character in Michael Maier's 1617
alchemical masterpiece *Atalanta Fugiens*. The great French
philosopher Gaston Bachelard summed it up wonderfully
when he said, "The poetic mystery is an androgyny."

From Hölderlin to Schlegel the German Romantics
saw androgyny as an idyllic state of reconciliation
and symbol of immortality, an idea they bequeathed
to surrealism. Today, the natural home for such
symbolism could be within the realm of comic books.

Since these multiple symbolic transmutations, the world
has witnessed a huge historical change in self-image,
accompanied by multiple visual innovations: photography,
cinema, and, obviously, comics. There is no need to look
back with nostalgia. Quite the contrary: if the alchemical
quest is lived through honestly, it should turn towards
the future. The fabulous artist Jean Giraud, known as
Mœbius, was more than familiar with these questions,
and has been largely responsible for introducing them
into the realm of science fiction with his friend Alejandro

Jodorowsky. Even Jean Giraud's pen-name is a kind of
game with the twofold logic of androgyny. It refers to
the mathematical object known as the Mœbius strip,
which represents the simplest non-orientable surface.
It is a loop that creates a surface with only one side.
Of course, Jean's choice was far from innocent:

> By changing from Giraud to Mœbius, I
> twisted the tape, changed dimension. I was
> the same and I was another. Mœbius is the
> result of my duality. The single identity
> made up of two distinct faces. A small
> metaphysical conundrum for private use.

Mœbius' interest in Hermes' thought patterns was clear
in his work, especially in *The Airtight Garage*. Its French
title, *Le Garage Hermétique* refers directly to the "hermetic"
quality of the quest. It was first published in serialized form,
Le Garage Hermétique de Jerry Cornelius, in the legendary
Franco-Belgian comics magazine *Métal Hurlant* from 1976
to 1979. The English-speaking public discovered the work
in the American version of the same magazine, *Heavy
Metal*. Jerry Cornelius is one of the avatars of the Eternal
Champion originally invented by Michael Moorcock. He is
a gender-fluid polymorph who travels the multiverse, well
before these concepts became hyped. Moorcock at one point
gave permission for Jerry Cornelius to be used by any artist
or writer who wished to. But despite the title, the hero is just
another character. The story mainly follows Major Gruber,
who orbits the garage/asteroid in his spaceship Ciguri.

Those familiar with the history of shamanism might
recognize that Ciguri is the name the Tarahumara tribe give
to the sacred peyote dance. Mœbius presented his work
both like a game and a quest for initiation, writing

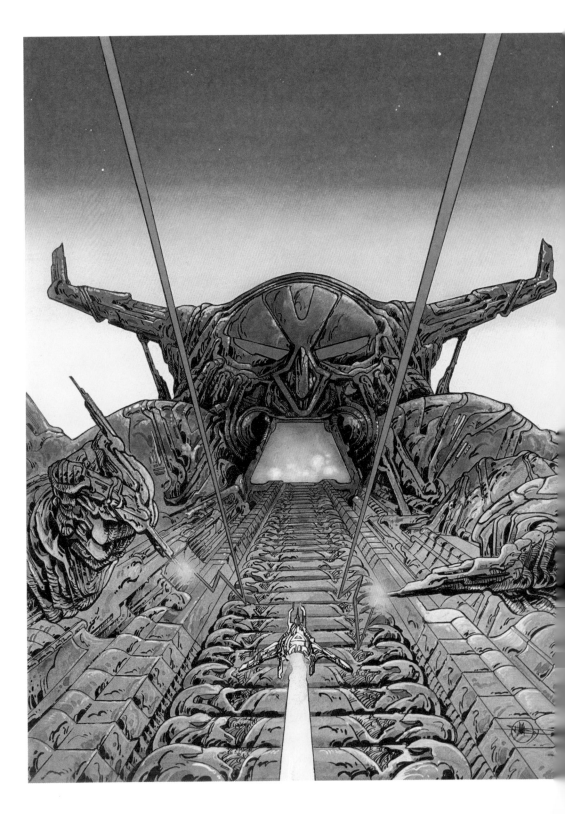

GUSTAVE FLAUBERT
GOES PUNK

Philippe Druillet
b. 1944
Salammbô
Volume 5 (cover)
1980

Highly respected in the art world, in 1974 Philippe Druillet became one the first comic-book artists to have his work make it into the auction houses. His rebellious kind of science-fiction was usually associated with rock'n'roll insurrection, so he surprised many with his 1980 steam-punk version of Gustave Flaubert's hallucinatory historical novel set in Carthage, *Salammbô*. This drawing was the cover for his Flaubertian experiment and was also the cover of the artist's monumental monograph.

PEACE AND LOVECRAFT

Philippe Druillet
b. 1944
Lone Sloane: Les îles du Vent Sauvage
Issue #553 *Pilote* magazine
1970

Druillet's work has had a surprising effect on filmmakers named George. George Miller said he found inspiration for *Mad Max* when reading Druillet's autobiographical comic, *La Nuit*. And despite the fact George Lucas' *Star Wars* seems very different, he prefaced a book by Druillet and clearly mentioned him as an inspiration in his work. Druillet is an expert at worldbuilding. Fighting against the values of his collaborationist family, he heralded an unprecedented type of "Peace and Lovecraft" use of ink.

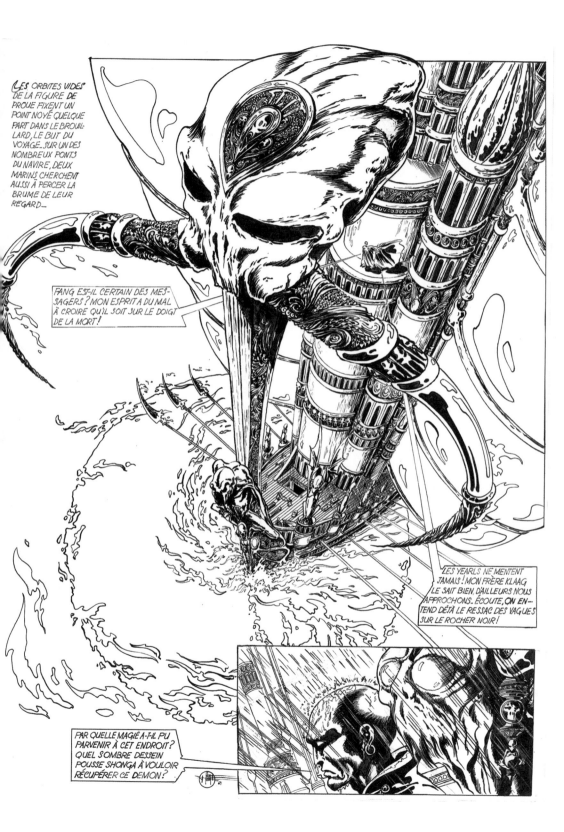

EGYPTIAN GODS AND THE INVENTION OF CHESS-BOXING

Enki Bilal
b. 1951
Nikopol
Volume 2, *La Femme Piège* (cover)
1986

With any luck, Paris in 2023 won't look like it does in this Baudelairean science-fiction epic. It tells the story of Nikopol, who, after serving thirty years in a cryopreservation prison, returns to Earth, only to find France under postnuclear, neofascist tyranny. The Nikopol trilogy is generally considered the masterpiece of French artist Enki Bilal. After working with important filmmakers like Alain Resnais and Michael Mann, Bilal adapted his own trilogy for the screen. Critics and public alike saw in the comics trilogy a groundbreaking renewal of the genre.

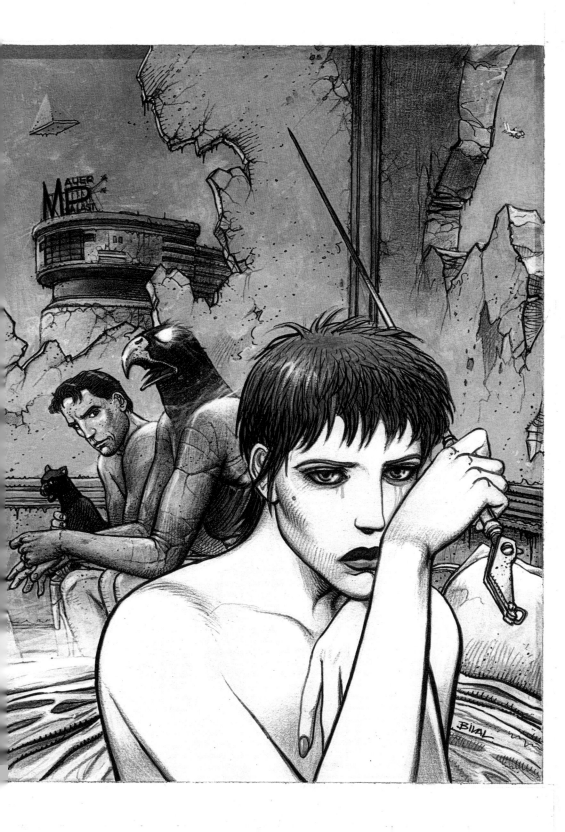

THE BIRTH
OF THE ATOMIC STYLE

Yves Chaland
1957–1990
Freddy Lombard
(unpublished)
1990

Yves Chaland, despite his untimely death, played an
essential part in the creation of the "atomic" style, along
with fellow artists Ted Benoit, Serge Clerc, and Floc'h.
Published by the magazine *Heavy Metal*, his clever pastiches
of the 1950s, which subvert the style invented by the school
of Marcinelle, used absurdist puns and witty literary
references to create a post-punk ethic.

EXPORTING ECO-FEMINISM TO THE OUTSKIRTS OF THE GALAXY

Jean-Claude Mézières (art)
1938–2022
Pierre Christin (text)
b. 1938

Valérian and Laureline
Volume 1, *The City of Shifting Waters* (cover)
1970

What happens when spatiotemporal agents decide that all alien species should be treated equally, that ecological concern should extend to parallel dimensions, and the jazzman Sun Ra travels to the twenty-eighth century to fight the robots that stole the United Nations' archives? With wit, humor, and tireless storytelling verve, illustrator Mézières and writer Christin showed that political commitment does not result only in proselytizing fiction. As if that wasn't enough, Mézières was also the only French comics author to spend his youth working as a cowboy in Utah.

J.C MEZIERES

Von crayonné fait pour placement et couleur des différents
éléments

"the hermetic garage is a real labyrinth. ... It is forbidden to stop the game before the end, or the player could be sent to a mental asylum." His work can remind us of what alchemists sometimes called a *ludus puerorum*: a very serious, but childlike, game.

This serious game can be seen as a kind of traveling island. One of the most philosophical comics of all is Hugo Pratt's *Mu: The Lost Continent*. Inside, readers discover Corto Maltese chasing Atlantis, which is not a sunken city, but an island that moves location on the map. Its geography literally changes through history. Quite like Mœbius' Major, who circles the garage in his shamanistic space ship, Corto travels through a very personal blending of Native American, Ancient Greek, and Arthurian mythologies. The moving island appears in other comic-book narratives and seems to define the very nature of the genre. It is most wonderfully depicted in *Hicksville*, a 1998 graphic novel by Dylan Horrocks and ode to comics and those who dream of creating them freely, outside corporate prerequisites. Recently the traveling island trope in comics seems to have entered a new phase of its evolution.

A 2022 auction at Christies attracted the attention of an unexpected audience. The celebrated auction house has thrived since 1766, and the collectors that come to bid are accustomed to surprises, such as the recent auction of *Salvator Mundi*, attributed to Leonardo da Vinci. It is now renowned as the most expensive painting ever sold and its sale was the subject of hours of documentaries, gossip, controversy, and intrigue. Making international headlines with ever bigger numbers and reputed masterpieces is something of a routine for the big auction houses and it takes a lot to ruffle this eighteenth-century tradition of escalating bids. But this particular auction stood out, and for multiple reasons.

At this auction, a group of crypto-enthusiasts had
the winning bid at three million dollars. The digital
counterculture has hacked its way into the high temple
of auctions, disrupting the status quo. They go by the
name of DAO-Dune, which stands for Decentralized
Autonomous Organization—a promising name, that
sounds like a moving island, a new type of Temporary
Autonomous Zone. They gathered what they call $Spice,
to help make the artwork for sale "become public"
through a future online library. And this is when the
story becomes stranger the fiction. The artwork is
legendary in the world of counterculture and comics: it
is the storyboard Mœbius drew for Jodorowsky's *Dune*.

This masterpiece is often known as "the most famous film
never made." The filmmaker Frank Pavich has even shot
a delightful movie about the way this one was not made.
For those who do not yet have the pleasure of knowing
Jodo, as his friends and fans call him, he is difficult to
portray. His Wikipedia page gives a flavor of this legendary
polymath and Franco-Chilean maverick, describing him
as a "novelist, screenwriter, a poet, a playwright, an
essayist, a film and theater director and producer, an actor,
a film editor, a comics writer, a musician and composer,
a philosopher, a puppeteer, a mime, a lay psychologist, a
draughtsman, a painter, a sculptor, and a spiritual guru."
No doubt some important skills have been forgotten, but it
gives an idea of how many different lives he has managed
to pack into his own. And if this does not confirm the idea
that comic-book authors are shape-shifters, nothing can.

Jodorowsky has created a seemingly endless list of
celebrated books and films, including a mythical adaptation
of *Mount Analogue*, the novel by the rebellious French
poet René Daumal first published in 1952. The film,
named *Holy Mountain*, was produced by Beatles manager

A GHOST, GOLDEN BULLETS, AND A SHAMANISTIC COWBOY

Jean Giraud, known as Mœbius and Gir (art)
1938–2012

Jean-Michel Charlier (text)
1924–1989

Blueberry
Volume 12, *Le Spectre aux Balles d'Or* (cover)
1972

Invented by the Belgian scriptwriter Jean-Michel Charlier, Blueberry is a shamanistic cowboy, often described as the enemy of discrimination of any kind. His adventures were illustrated by the virtuoso French comics artist Jean Giraud, known as Mœbius, in a style that he had perfected by assisting his master in comic-book westerns, Jijé. Blueberry's adventures ran for fifty-five albums, from 1963 to 2005, with Giraud assuming the writing after the passing of his partner. This album is key in the development of the character's spiritual dimension.

Allen Klein, since John Lennon, George Harrison,
and Yoko Ono appreciated Jodo's work, and financed
parts of it. As Daumal wrote in his novel: "The path of
greatest desires often lies... through the undesirable."

Jodorowsky's desire to adapt Frank Herbert's *Dune* changed
the history of both cinema and comics, while narrative art
was transformed by this project. The so-called Dune Bible is
a legendary sci-fi object. If it was never filmed, it nonetheless
brought together artists and ideas that have since inspired
projects like Star Wars, Alien, and Blade Runner. The cast
and crew were impressive: H.R. Giger for the stage-design,
Orson Welles as Baron Harkonnen, Salvador Dalí as the
Emperor, Pink Floyd for the soundtrack. The list of famous
talents went on and on. What attracted the crypto-crazy
$Spice gatherers was obviously the storyboard, with over
three thousand illustrations drawn by Jean. The first to
broadcast the news was *NEWSBTC: Bitcoin & cryptocurrency
news*. These Decentralized Autonomous Organizations,
who seem to believe in sharing art with everybody, make
one feel like there might be a new DAO-ism in town.

Comic-book making depends on very low-tech, ancient
methods and materials: paper and ink, but there has been
an intrinsic link between cyberpunks and comics, hacker
culture and sci-fi, counterculture and whistleblowers.
Whoever is behind this particular DAO, the very idea
carries the potential for a new, free creativity. Some
might believe a highly technological environment could
be detrimental to comics, but, in the words of Alan
Moore: "I think that in an increasingly virtual world,
lovingly produced artefacts are at a premium."

A crypto-androgynous hermetic artwork is still to come.
It could work along the famous and elegant lines of Donna
Haraway's *Cyborg Manifesto*: "Cyborg imagery can suggest a
way out of the maze of dualisms in which we have explained
our bodies and our tools to ourselves. This is a dream not of
a common language, but of a powerful infidel heteroglossia."

Let's hope many freethinking tricksters will use the
tools of this medium, and invent a new symbolism that
will keep the art popular, while avoiding populism.

Let's hope the dreamwork has hardly begun.

DIVING INTO COSMIC CONSCIOUSNESS

Mœbius, born Jean Giraud (art)
1938–2012
Alejandro Jodorowsky (text)
b. 1929
L'Incal
Volume 1, *L'Incal noir* (opening page)
1981

This opening sequence is a rare encounter between poetic-prophetic writing and dreamlike drawing. When looking at this historic page, one wonders: is John Difool, the hero of *L'Incal*, falling through suicide alley or diving into cosmic consciousness? John Difool is the starting point of the story, like the tarot's Fool. In his book *The Way of Tarot*, Alejandro Jodorowsky explains: "The key phrase of the Fool could be 'All paths are my path.'" Like John Difool, the reader falls into a vortex of fiction that will change his perception.

META-BARONS WERE META WELL BEFORE THE METAVERSE WAS BANKABLE

Juan Giménez (art)
1943–2020
Alejandro Jodorowsky (text)
b. 1929

The Saga of The Meta-Barons, 1992–2003
(cover)
2008

Influenced by Hugo Pratt and Héctor G. Oesterheld and obsessed with airplanes, the artist Juan Giménez started his collaboration with Jodorowsky by focusing on the Meta-Barons dynasty, a spin-off from the Incal universe. In this he developed a very personal use of color and ornate weaponry. The spiritual warriors described in the lyric epic struggle with questions of technological prosthetics, lineage, and imperialism. It is one of the first comics ever to envision the metaphysical consequences of cyborgs.

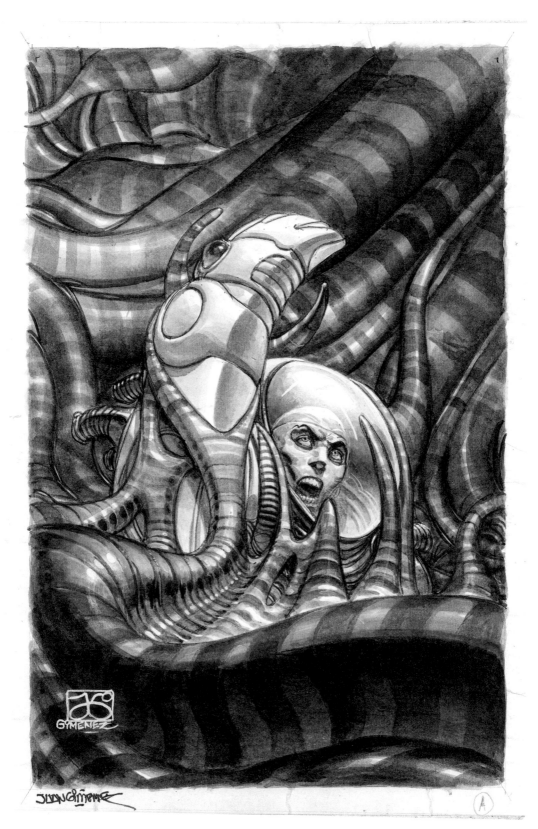

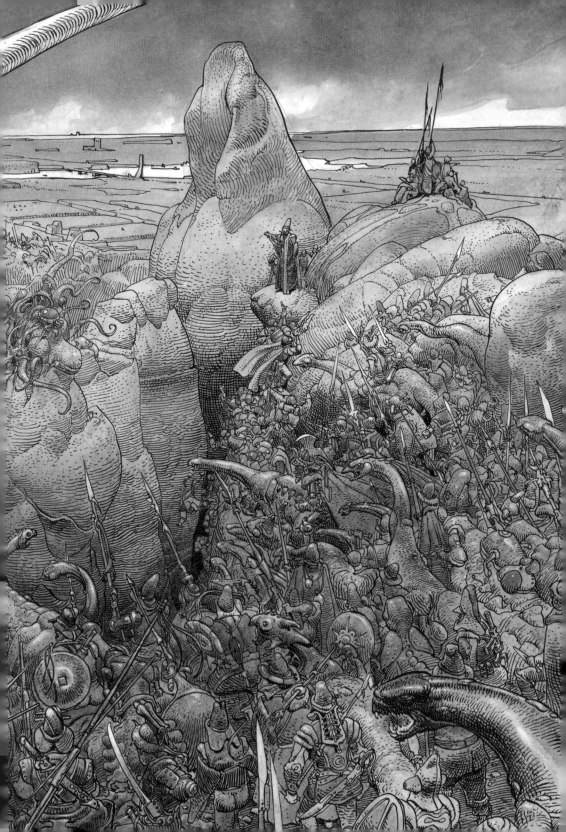

THE ANGEL'S PERSPECTIVE

Mœbius, born Jean Giraud
1938–2012
Histoire n° 4, Harzakc
(pages 4 and 5)
1975

One sunny afternoon, Mœbius developed a theory to explain his work. He saw three main categories of perspective in his drawing: the perspective of Lucifer (which starts from above and tumbles downward), the perspective of Icarus (which starts in the abyss and points upward to the ether), and the perspective of the Angel (which takes the diagonal). The Angel's perspective was a kind of Grail for him. We see this diagonal perspective very clearly in this masterpiece, the battle scene of *Arzach*.

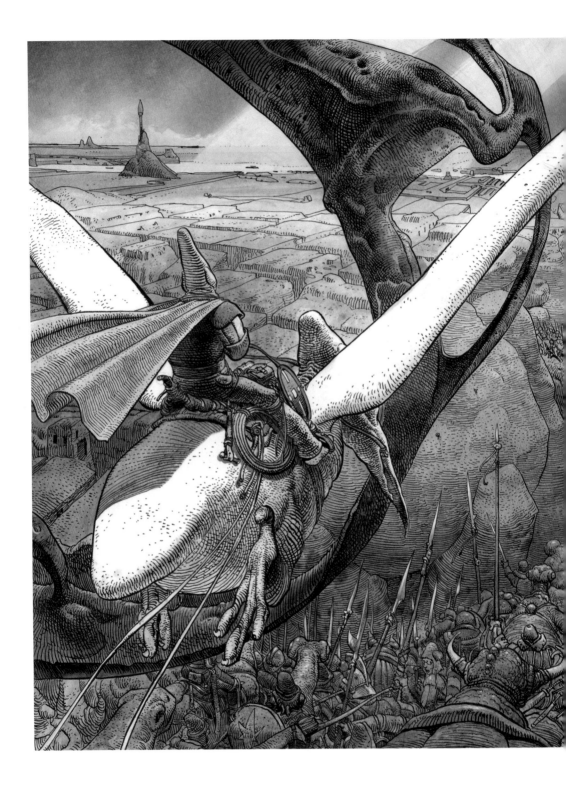

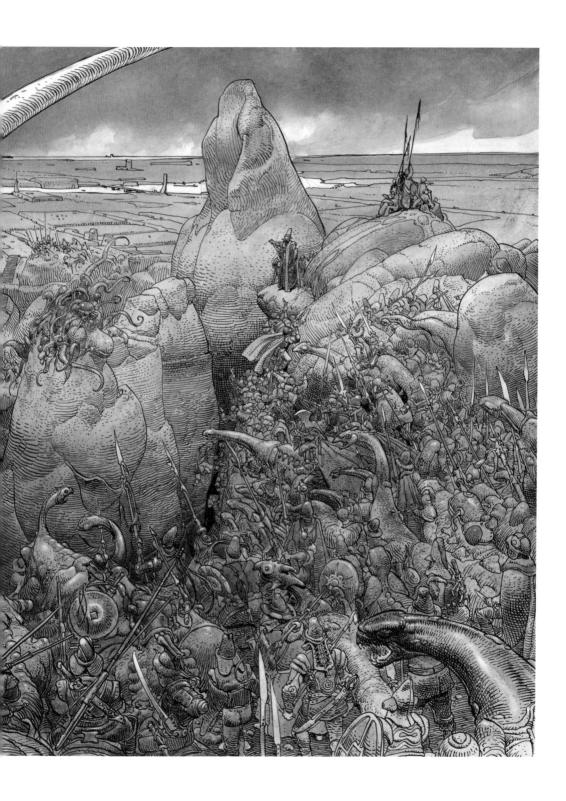

PHOTOGRAPHIC CREDITS

In reproducing the images contained in this publication, the Publisher obtained the permission of the rights holders whenever possible. Should the Publisher have been unable to locate the rights holders, notwithstanding good-faith efforts, it requests that any contact information concerning such rights holders be forwarded so that they may be contacted for future editions.

COLLECTORS

We would like to warmly thank for their collaboration in this project:

Paco Baena
Lukas de Broutelles
Lluís Giralt
Pierre-Henry Lenfant
Jean-André Macchini
Thierry Mallet
André Querton
Vicent Sanchis
Vicente Segrelles
along with four anonymous
private collectors
and the institutions:
Galerie Champaka
Heritage Auctions, Dallas

We would like to thank
Inma Machí for her discreet
but important role
in the genesis of this project.

Drawings on pages 7, 14, 58, 98, 176, 216, 254 are by Damien MacDonald

Simultaneously published
in Spanish and Catalan

as *Anatomía del cómic.*
Láminas célebres del arte narrativo

and *Anatomia del còmic:*
originals famosos de l'art narratiu
© Flammarion S.A., Paris, 2022

English-language edition
© Flammarion S.A., Paris, 2022

Flammarion S.A.
87, quai Panhard-et-Levassor
75647 Paris Cedex 13
editions.flammarion.com
@styleanddesignflammarion

22 23 24 3 2 1
ISBN: 978-2-08-028187-6
Legal Deposit: 05/2022

Printed in Barcelona (Spain) by Indice

Interior page paper stock:
Munken Kristall Rough 150gsm (FSC)
Cover paper stock:
Prisma Up Silk 300gsm (FSC)

FRONT COVER
Charles Burns
b. 1955
Métal Hurlant
Issue #120 (cover)
1986

FLAPS
Chris Ware
b. 1967
What I May Have Learned Thus Far
2004